THE LOOK OF LOVE

For Esme, Ian, Deborah, and James Patrick

The Look of Love

THE ART OF THE
ROMANCE NOVEL

by Jennifer McKnight-Trontz

Princeton Architectural Press New York

Published by
PRINCETON ARCHITECTURAL PRESS
37 East Seventh Street
New York, NY 10003

For a free catalog of books, call 1.800.722.6657.
Visit our web site at www.papress.com.

Editor: Mark Lamster
Book design: Jennifer McKnight-Trontz
Cover design: Deb Wood
Proofreading: Noel Millea

Special thanks to: Nettie Aljian, Ann Alter, Amanda Atkins, Nicola Bednarek,
Janet Behning, Megan Carey, Penny Chu, Jan Cigliano, Jane Garvie,
Tom Hutten, Clare Jacobson, Nancy Eklund Later, Linda Lee, Anne Nitschke,
Evan Schoninger, Lottchen Shivers, and Jennifer Thompson
of Princeton Architectural Press—Kevin C. Lippert, publisher

Credits: *Ann Kenyon: Surgeon, White Fawn, Afterglow, The Moon's Our Home,
Golden Earrings, Self-Made Woman, Home Town Doctor, Sons of the Sheik, Kind
Are Her Answers, Skyscrapers,* and *Return to Night* used by permission of Dell
Publishing, a division of Random House, Inc. *Quality, The Doctor Is a Lady, A
Nurse on Horseback, Women Will Be Doctors, Nurse into Woman, Symphony in the
Sky,* and *Illusions* used by permission of Bantam Books, a division of Random
House, Inc. Pocket Books featured by permission of Simon & Schuster. *Brief
Golden Time, A Baronet's Wife,* and *Devil's Mansion* courtesy of Warner Books.
*Fair Stranger, General Duty Nurse, Doctor in Bondage, Desert Nurse, Nurse
Barlow, The Hospital in Buwambo, Wife by Arrangement, Corporation Boss, First
Love Last Love, Scorched Wings, Strange Bedfellow, Tabitha In Moonlight, The
Tender Night,* and *I'll Be with You* courtesy of Harlequin Enterprises Ltd.
*Linda's Champion Cocker, Doctor Myra Comes Home, Once Upon A Summer, The
Doctors, Society Doctor,* and *Air Stewardess* used by permission of Avalon Books.
The Barbarian Lover by Margaret Pedler and *Shadow of Roses* by Hermina
Black used by permission of Hodder and Stoughton Limited.

Library of Congress Cataloging-in-Publication Data
McKnight-Trontz, Jennifer.
 The look of love : the art of the romance novel / by Jennifer
McKnight-Trontz.
 p. cm.
 Includes bibliographical references and index.
 ISBN 1-56898-312-3 (alk. paper)
 1. Book jackets–United States–Design–Catalogs. 2. Illustration
of books–United States–Catalogs. 3. Romance fiction–United
States–History–20th century. I. Title.
 NC1882 .M39 2002
 741.6'4'0973075–dc21
 2001005122

Contents

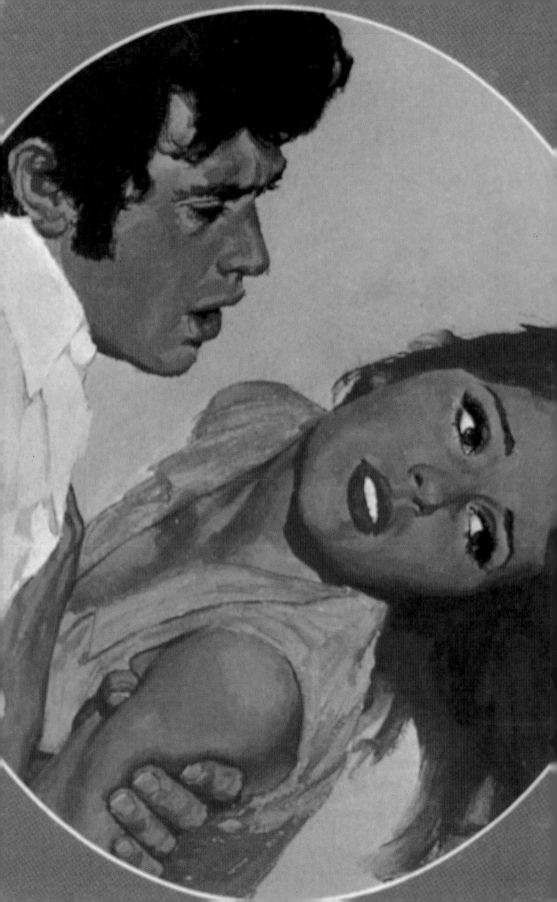

Acknowledgments

I thank all of the authors whose books are included here for bringing so much pleasure to so many women, despite the wrath of critics; the art directors and illustrators who created these wonderful covers; and the publishers who built the romance book industry. I am particularly grateful for the assistance of Shelley Cinnamon at Harlequin Books, Robert Maguire, Robert McGinnis, and Gary Lovisi. Thanks also to editor Mark Lamster and Princeton Architectural Press for taking on this labor of love.

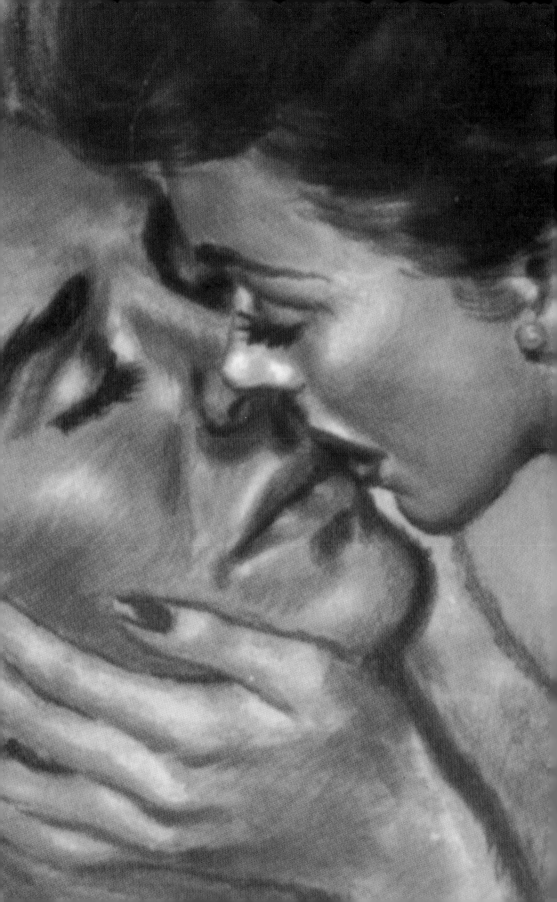

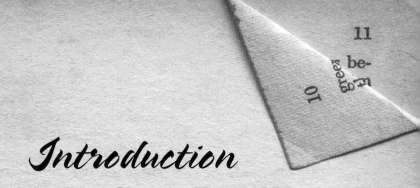

Introduction

I n the 1940s, the advent of the mass-market paperback forever altered the publishing industry and changed the way countless millions of readers consumed fiction. Offering hungry audiences popular entertainment rather than more rarified forms of literature, the new softcover books bore few pretensions and were sold for pennies at stores and shops of all kinds. Their fantastic tales of adventure, crime, mystery, and romance allowed readers a bit of escape from the tedium and regimentation of modern life.

If men were attracted to tales of sex and violence, women wanted romance, and the pocketbook-friendly paperback proved an ideal format. From prim and proper tales of refined ladies and gentlemen to daring and bold stories of love and longing, women lost themselves in the pulp-paper pages of their romance novels. For a slightly lighter change purse, the worlds of the rich, the beautiful, the notorious, and the innocent were theirs to have, if only for a day—or a few minutes a day. In an era before sexual liberation and the Pill, romances offered female readers a taste of illicit freedom. And with so many options to choose from, the bright, colorful covers of romance novels became crucial sales tools for their publishers. An entire genre of fiction was sold based on the premise that you could, in fact, tell a book by its cover.

Though tame by today's standards—and in comparison to the more racy paperbacks produced for contemporary male audiences—the early romances were fairly provocative. Over time, however, the books became more explicit, and sales rose with the added heat. Published in increasing numbers since the 1940s, by the 1970s the paperback romance novel had blossomed into a worldwide phenomenon. Romance readers did not require elaborate plotting, complex character development, or deft handling of language from their authors. They were more than happy with stories whose purple prose stuck to a basic formula: woman meets man, complications arise, obstacles are overcome, the two lovers marry.

Romance fiction and paperbacks were not entirely new in the 1940s—women had been reading romance novels for centuries. The Brontë sisters' *Jane Eyre* and *Wuthering Heights* were bestsellers in the 1800s. Hardcover editions of romance novels with subdued, artfully illustrated covers were widely enjoyed by women in the early part of the twentieth century. Romance authors such as Faith Baldwin and Margaret Mitchell enjoyed tremendous popularity during the 1930s. And the paperback, too, existed in some form throughout the nineteenth century in the United States and Europe in the guise of penny dreadfuls, dime novels, and cheap libraries.

The first English-language, mass-market paperback was indeed a romance, *Malaeska* by Ann S. Stephens, published in June 1860 by Erastus and Irwin Beadle, pioneers of the dime novel. The success of this romantic tale (it sold sixty-five thousand copies within a few months of publication) of an Indian princess was such that it helped launch a whole new genre in publishing. These early dime novels usually featured a paper cover with a simple woodcut illustration depicting a scene from the story. Though these books flourished for a time,

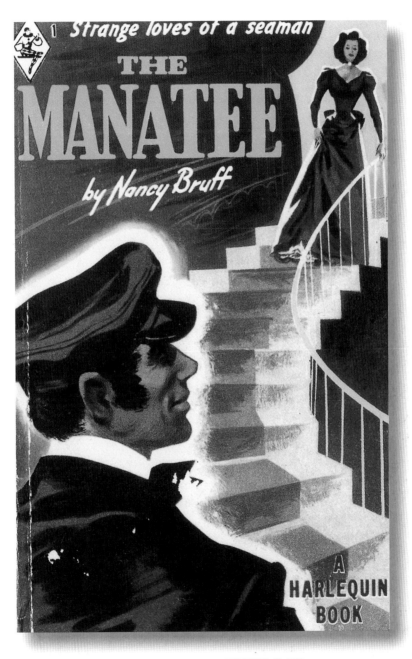

PUBLISHED IN 1949, *The Manatee* was
the first title from the Canadian
publishing house Harlequin Books.
Harlequins are now printed in
twenty-four languages.

sensational pulp magazines exploring the same terrain (Westerns, crime, and romance) eclipsed them in popularity beginning in the 1890s. In the 1930s a few paperback publishers existed, such as Boni, Modern Age Books, and American Mercury Books, but their success was to be short-lived.

It was not until Robert de Graff's Pocket Books debuted in 1939 that mass-market paperbacks and romances came of age. De Graff believed he could make a success of his paperbound, 4.25-by-6-inch "Pocket Books" by selling them like magazines—in bookstores, newsstands, drugstores, and cigar stores. By keeping production costs low (with newer, more efficient presses) and by selling hundreds of thousands of copies through a well-organized distribution system, their price could be kept to just 25 cents, a bargain, even then.

By 1943, numerous other publishers had launched similar lines, such as Bantam Books (sold from vending machines), Avon, Popular Library, Dell, and New American Library, but as historian Janice Radway has noted, "it was de Graff's ability to institute this system on a large scale that set the stage for the romance's rise to dominance within the mass-market industry."[1] What stood out about these new paperbacks, compared to higher-brow softcovers, such as those from the British publisher Penguin, were their attractive, eye-catching covers that were designed to lure potential readers into the stories. They were also less expensive. The Penguin books, under the design direction of legendary modernist typographer Jan Tschichold, were relatively subdued in their cover art, often featuring only the title of the book between orange bands. By the end of the 1940s, Penguin's American branch began to feature full-color cover illustrations, though its parent company in England did not follow suit until the 1960s.

As nearly all early paperbacks were reprints of hardcover editions, the paperback publishers competed aggressively for reprint rights. As late as 1955 only one-third of paperbacks were originals. Hardcover publishers, such as Dodd, Mead & Company, Thomas Bouregy & Company, and Doubleday provided much of the content to the paperback romance houses. The first serious challenge to Pocket Books' almost exclusive control of cheap reprint book sales was Avon's "pocket-sized" series. Its romance line included such saucy titles as *The Hard-Boiled Virgin*, *Kept Woman*, and *The Abortive Hussy*. Most were fun romps through the loves of well-bred urbanites, as in Katharine Brush's *Young Man of Manhattan*: "Ann Vaughn and Toby McLean thought they were just made for each other. She was vivacious, peppy, and a writer for the *Star*. He was a zesty reporter on the same paper. When these two healthy young people met one rainy afternoon— a sparkling brunette and a handsome ex-gridiron star—why they just naturally decided to get married."[2] The cover features the glamorous couple embracing (but not kissing) in front of the Manhattan skyline.

Also following de Graff and Pocket Books was George Delacorte Jr., who by the age of twenty-eight had built a profitable business publishing mass-market magazines and comic books through his company, Dell Publishing. Delacorte was known as a man who understood what the general public wanted. By the 1940s they wanted paperbacks, and in 1943 Delacorte met the demand. Dell, which had published such pulp magazines as *I Confess* and *Cupid's Diary* early on, concentrated on romances. Typical titles included *Afterglow* by Ruby M. Ayres and reprints of Faith Baldwin romances from the 1930s, such as *The Moon's Our Home* and *Woman on Her Way*. Dell continued to focus on romances into the 1950s and 1960s. Its reprints of Victoria Holt's

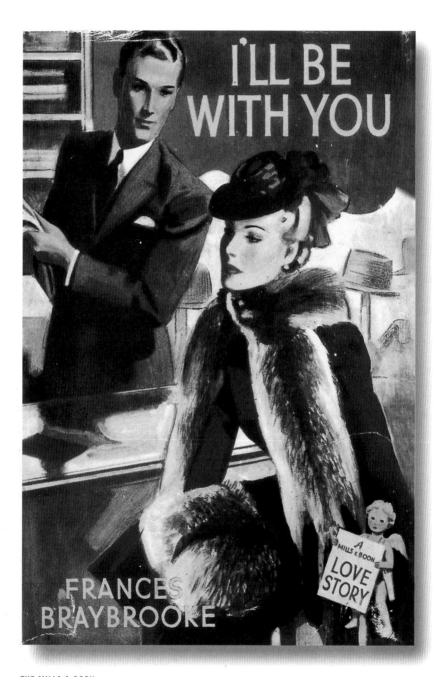

THE MILLS & BOON cover for *I'll Be with You*, from 1943, is typical of the glamorous, subdued romance hardcovers of the early 1940s.

popular Gothic romances in the 1960s played a significant role in solidifying the romance paperback habit. Bantam, another romance publisher, was founded in 1945 by Ian Ballantine, and was home to such popular authors as Emilie Loring, Marguerite Marshall, and Grace Livingston Hill. Over the decades other paperback publishers followed suit: Ace, which published the first modern Gothic novel, Pyramid, Fawcett, Signet, Monarch, Valentine, Belmont, Macfadden, Magnum, Paperback Library, and Airmont all published popular romance fiction.

Then, in 1949, a onetime fur trader for the Hudson Bay Company and former mayor of Winnipeg named Richard H. G. Bonnycastle founded a small Canadian paperback-only publishing company: Harlequin. In its first year, Harlequin put out a line of general fiction and educational materials, as well as a few romance titles, including *The Manatee: Strange Loves of a Seaman* and *Honeymoon Mountain: Deborah Loses Her Innocence*. Over the next decade it published several more "nice little romances," as Bonnycastle's wife, Mary, called them. She, along with Harlequin secretary Ruth Palmour, initially read the manuscripts. Palmour may also have illustrated some of the early covers. The romances proved to be the company's greatest asset, and Harlequin soon found itself searching for a partner to provide content. Palmour approached Mills & Boon, a British hardcover house, seeking reprint rights to its popular romance titles, and in 1957 Harlequin began distributing Mills & Boon romances under its own imprint—the first was Anne Vinton's *The Hospital in Buwambo*.

Founded in 1908 by Charles Boon and Gerald Mills, Mills & Boon published sweet, but not spicy, romances and was known to carefully monitor its authors and storylines. A Mills & Boon hero-

ine, for example, would not stay overnight in a man's apartment before marriage. The publisher also tended to avoid troublesome subjects and situations. This approach matched Harlequin's, and made for a healthy relationship between the two publishers, who both sought readers attracted to "wholesome" stories.

By 1964 Harlequin was publishing only romances, and the wholesome heroine—honest, sincere, pure, and innocent—was its signature. These books were nothing if not formulaic: the Harlequin reader expected to follow the story, set in an exotic locale, of a virginal young woman who falls in love with a man of means. A tempestuous courtship would ensue with periods of misunderstanding and uncertainty, but all would end well with a wedding. The sexual element was subdued, limited to an embrace or a kiss. Premarital or extramarital sex was absent entirely. In 1972 Harlequin formally merged with Mills & Boon, and began to publish original titles as well as reprints (still adhering to its tried-and-true formula). With its acquisition of Simon & Schuster's Silhouette imprint in the 1980s, Harlequin became the world's leading publisher of romance fiction.

The success of the paperback romance phenomenon was propelled in no small measure by the exuberant covers that graced these books. From the 1940s through the 1970s, romances were illustrated by some of the most talented and sought-after illustrators in the publishing industry, most of them men. Such notable graphic artists as Robert Maguire, Baryé Phillips, Robert McGinnis, Gerald Gregg, Lou Marchetti, and Mitchell Hooks all designed romance paperbacks. Their talent and rate of execution were remarkable. Phillips, whose prodigious output of a cover per day earned him the moniker "King of the Paperbacks," is perhaps best known for his 1958 cover for Jack Kerouac's *On the Road*.

While "quality" paperbacks, such as Dover Books, Penguin, Anchor, and Vintage, were somewhat restrained in their cover designs, mass-market books were generally bright and colorful. As the historian Thomas L. Bonn has noted, "publishers became convinced that they were competing as much with magazines as with hardcover books. Consequently, paperbacks were increasingly outfitted as 'miniature magazines,' to do battle for display space."[3] Eye-catching and sometimes sensational, covers helped them compete.

In stores, paperbacks were generally categorized by publisher. For example, all Bantam books—romances, mysteries, and adventures—shared the same rack. This left publishers with two problems: they had to distinguish their books from those of other publishers, and they had to make clear distinctions between the titles from different genres in their own lists. Standard cues for romance books were pastel colors, flowers, and embracing couples. Several publishers followed the lead of Albatross, an English paperback house that color-coded its covers blue for love stories. Prior to the 1970s, when script became the type of choice, the lettering on romance covers was indistinguishable from that of other paperbacks, usually a simple serif or sans serif typeface. The words employed said enough: "cherish," "lover," "mistress," and "memories" were typical.

Most genre fiction covers, romance included, depicted a single scene from the book they advertised. Pulp-inspired art is evident in many romance covers (remember, they were created by the same illustrators and art directors as other pulp fiction), but in general romance covers maintained a certain level of dignity—romance readers did not want scantily-clad femme fatales. This may be the defining difference between a romance cover and a lurid, "sleaze" cover for a pulp novel aimed at a male audience.

While the characters in both books may indeed end up in the same place—the bedroom—there are no torn clothes or sordid poses on the romance cover. At least not until the 1970s, and then it was usually the man who bared his chest.

If the cover artists were generally realists in their drawing styles, they managed to imbue their romance designs with enough fantasy to make them appealing to women. If there was a certain dependence on a set of cliché compositions—a hero and heroine who gaze longingly into each other's eyes; a contemplative woman in the foreground with her lover milling around in the background—publishers and readers seemed not to care.

Inevitably, the covers relate something of the period in which they were drawn, particularly in regard to women's roles in society. Covers of the 1940s, especially those created during World War II, allude to the preciousness of family and home. By the time the war was over, heroines—with a newfound independence—were determined to take life less seriously. Postwar covers often portray beautiful men and women on social escapades—*Young Man of Manhattan* being a fine example of this type of jaunty tale. Women also had marriage on their minds (when had they not?), and many titles addressed the various complexities of tying the knot. These covers often featured a woman looking anxious or pensive.

Some of the most stunning covers of the 1940s were produced by Dell staff artist Gerald Gregg, who earned a reputation for his exquisite airbrush technique. Calling his style a combination of graphic design and stylized realism, Gregg used contrasts of light and shadow with the addition of a few bright colors to accentuate particular features of his characters. Today, these and other early Dell paperbacks are collected for their front covers as well as the maps that appeared on their backs. Called "map-

backs," these early editions featured handsome plans that corresponded to a principal scene or location in the book. Serious about accuracy, Dell's editors determined which part of the plot in-house mapmaker Ruth Belew would depict. The maps quickly became as much a part of the Dell identity as the company's keyhole logo, which was used to distinguish the various genres the company published: for mysteries, the keyhole enclosed an eye; for romances, a heart. In 1951, Dell replaced its unique maps with conventional blurbs.

Making the difficult choice between man and career was a standard travail for romance heroines during the 1950s. Covers for these titles generally featured a heroine in her place of work, often posed before an office window. By the 1960s it had become readily apparent that medicine was the career of choice for women readers. In 1961 alone, Harlequin titles included *Doctor to the Isles*, *Wife to Doctor Dan*, *Children's Hospital*, *Nurse Angela*, *Nurse Nolan*, *Nurse Templar*, and *Yankee Surgeon*.

The doctor/nurse romances quickly became fixtures with nearly all romance publishers, and by the late sixties the material had become so well-trodden that publishers were resorting to the most unlikely of scenarios. Titles such as *Everglades Nurse*, *Settlement Nurse*, and *Jungle Nurse* placed medical professionals in bizarre predicaments and exotic locations, and the covers often show the heroine in her uniform surrounded by a threatening landscape. Romance writers had fun with the nurse, often merging her story with other typical romance themes, as in *Beauty Contest Nurse* and *Society Nurse*.

Concurrent to the nurse/doctor phenomenon was the explosion in popularity of Gothic romances. The demand for Gothics grew to such proportions that by the late 1960s works of top Gothic authors outsold the works of equivalent writers in all

other categories of paperback fiction, including mysteries, science fiction, and Westerns. The Gothic romance covers were easy to pick out: they nearly always featured a raven-haired beauty at the fore and a mansion with a single light on in the background.

By the 1970s, the way women thought about themselves in the workplace had begun to fundamentally change, and this was reflected in the romance novel. "Heroines started hammering on the glass ceiling in the 1970s," according to Harlequin editor Marsha Zinberg, "and sparks soon flew between men of the world and smart, spirited women who had every intention of building their careers."[4] The changing male/female power structure was portrayed on the cover of Harlequin's own *Corporation Boss,* by Joyce Dingwell. The novel reads: "When they had first met, Constance knew Anthony Vine had been interested in her. But now that she had come to work with him at Corporation City in the Northern Territory, he was cold and distant. What had gone wrong between them, and was there anything she could do about it?"[5] More and more women were featured as bosses, not just secretaries.

While Harlequin maintained its deliberately old-fashioned art program, in the 1970s other romance publishers shifted toward more explicit sexual content on their covers. As the late 1960s freed society from some of its hang-ups, what was considered "taboo" in the 1940s and 1950s hardly received a second glance by the 1970s. Charming innuendo was lost; it wasn't needed anymore. You could feature a rapturous embrace, a passionate kiss, or a man with his shirt off on the cover of a romance novel without consequence. Previously, artists could only hint at lust, which resulted in far more creative scenes, as on the cover of the

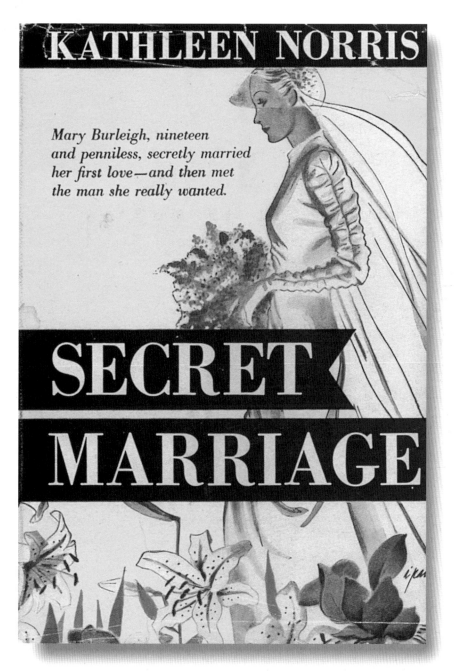

KATHLEEN NORRIS

Mary Burleigh, nineteen and penniless, secretly married her first love—and then met the man she really wanted.

SECRET MARRIAGE

PRIOR TO THE PULP magazine–inspired covers of the 1940s, many hardcover romance books featured illustrations that were sweet and conservative, such as this one for *Secret Marriage.*

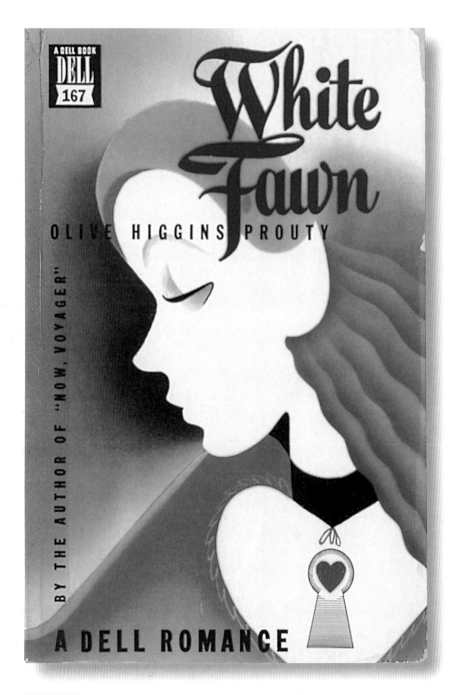

AN EARLY DELL paperback, *White Fawn* features the publisher's keyhole logo with a heart for romance. Hand-rendered lettering was unusual for most paperbacks, but Dell often featured it.

1962 title *Young Doctor Elliot*, where the handsome doctor hovers over a sexy blonde patient lying on a bed (presumably in the doctor's office). Dr. Elliot's hand reaches out, but is to examine her? Her low-cut blouse and fresh lipstick indicate that her intentions, as well as the doctor's, may not be innocent.

By the early 1970s, with sales of Gothic romances beginning to decline, publishers began to suspect that the growing visibility of the feminist movement and increasing openness about female sexuality were leading women to romances with more explicit sexual encounters. So the publishers put out. In the early 1970s Avon Books launched a new series of steamy historical novels. Its first blockbuster was Kathleen Woodiwiss's *The Flame and the Flower*, which, at 350 pages, was nearly three times as long as the typical romance and included explicit descriptions of sexual encounters and near-rapes. The back cover read: "In an age of great turmoil, the breathtaking romance of Heather Simmons and Captain Brandon Birmingham spans oceans and continents! Their stormy saga reaches the limits of human passion as we follow Heather's tumultuous journey from poverty...to the splendor of Harthaven, the Carolina plantation where Brandon finally probes the depths of Heather's full womanhood." With Rosemary Rogers's *Sweet Savage Love,* the second contribution to this new subgenre, the "sweet savage romance" found its name. These risqué titles portrayed high-spirited women who ultimately won not only love but also respect and independence.

The sweet savage romance covers were often illustrated by the same artists who had created the earlier, more proper romance covers. Robert McGinnis, who had been creating art for romance covers for decades, illustrated *The Flame and the Flower*. But the mood was different—more passionate and erotic—with

full-fledged embraces. While sentimentality and innuendo had once been an integral part of romance cover art, the new formula consisted of a bare-chested hero forcing a long-haired heroine into a steamy embrace. Termed "the clinch," this type of rapturous embrace dominated future romance covers.

Sex sold. Approximately four-hundred trade and mass-market imprints peddled romance books in the late 1970s—paperback publishers were no longer competing with magazines, but with an ungodly number of other titles. Paradoxically, many of the covers began to look alike. As historian Carol Thurston wrote in *The Romance Revolution*, "Success tended to beget more of the same rather than innovation and variety, in spite of the increased number of competing publishers. Settings, plots, and characters, as well as titles and cover illustrations, were sometimes so similar that readers soon began to suspect, 'I've read this one before.'"[6]

One aspect of romance fiction that has changed little over the decades has been the savage treatment it has received from literary and cultural critics. As John Tebbel has written, "romance novels, which register the highest sales figures of any genre, are regularly deplored for their lack of any quality other than entertainment. They were deplored in much the same terms before the Civil War, and in even stronger words before the end of the [nineteenth] century."[7] Even after more forceful roles for female characters became prevalent in the 1960s, the harshest and most biting critiques came from women themselves. Beyond their lack of literary merit, scholars complained that romances portrayed women as submissive and weak: in an article titled "The Ugly-Pretty, Dull-Bright, Weak-Strong Girl in the Gothic Mansion,"

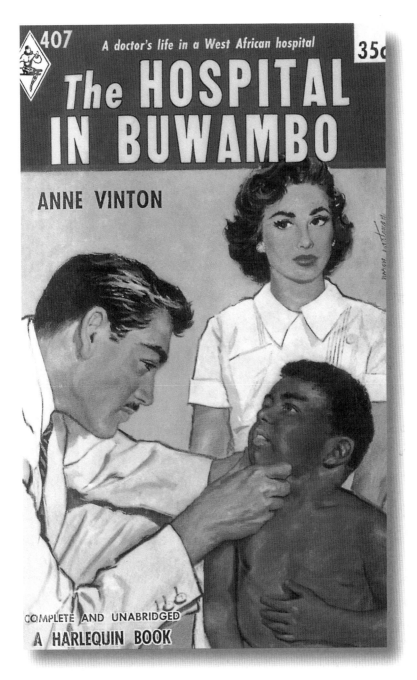

THIS COVER FOR *The Hospital in Buwambo*
(Harlequin Books, 1957) features components
typical for a romance cover: a tropical setting,
an attractive couple, and a sense that some-
thing romantic has just or will soon happen.

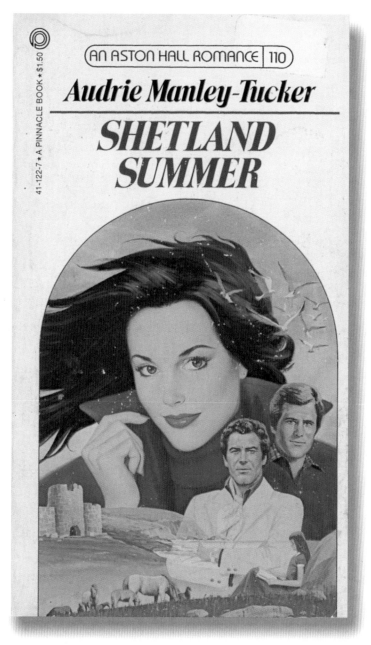

AN ASTON HALL ROMANCE | 110

41-122-7 ★ A PINNACLE BOOK ★ $1.50

Audrie Manley-Tucker

SHETLAND SUMMER

THIS COVER FOR *Shetland Summer* is
typical of the 1970s. White was the
color of choice, and illustrations took
up less space than the full-bleed covers
of the 1940s and 1950s.

Caesarea Abartis concluded that the modern Gothic romance teaches readers to be "passive and hanker after mansions." Marian Starr, in "Sweet-Savage Book: The Romance in America, 1855–1980," claimed romances were antifeminist, pro–status quo, and generally bad for women. A British Archbishop went so far as to blame the highly romantic expectations created by such entertainment as Mills & Boon novels for Britain's rising divorce rate. Critiques like these left many romance lovers ashamed and embarrassed. For a time, Harlequin offered fake book covers to hide the telltale originals.[8]

Incessant criticism has had little, if any, effect on sales. Women have never stopped reading romances, and sales have long dwarfed those of other genres. Romance titles have sold more copies than any other genre in the history of publishing. And their popularity is not confined to the English-speaking world. Harlequin, the largest contemporary romance publisher, prints books in twenty-four languages and distributes in one-hundred countries, selling more than one-hundred million books each year.

So what exactly is the attraction? According to two current romance authors, Linda Barlow and Jayne Ann Krentz, "The reader trusts the writer to create and re-create for her a vision of a fictional world that is free of moral ambiguity, a larger-than-life domain in which such ideals as courage, justice, honor, loyalty and love are challenged and upheld."[9] A more libidinous temptation may be the desire for a "dangerous hero." As far back as 1850, the most widely read periodical for women, *Godey's Lady's Book*, lamented the popularity of books about working-class men who moved upward into the genteel class, where they didn't

belong. This type of man was considered dangerous to the care-
fully constructed social hierarchy. The Mills & Boon heroes,
according to the founder's elder son, Alan Boon, were "alpha
men—strong mentally and physically tough, intelligent, tall and
dark. The 'honest Joe' type of man may make a good husband, but
he's not exciting enough for our readers." In her analysis of the
genre, *Reading the Romance: Women, Patriarchy, and Popular
Literature*, Janice Radway concluded that the romance's popular-
ity stems from the ways these stories address—or elide—anxi-
eties, fears, and psychological needs resulting from the middle-
class woman's social and familial position, and how the act of
reading fits within her daily activities.[10]

Though there is no question about the popularity of the
romance genre as a whole, the success of specific publishers is
now heavily reliant on marketing and distribution techniques. As
early as the 1970s, Harlequin president W. Lawrence Heisey, a
former executive for Proctor and Gamble, argued that the quali-
ties of the product itself were unimportant in designing sales
campaigns. "Of greater significance," said Heisey, "is the ability
to identify an audience or consuming public, the discovery of a
way to reach that audience, and finally, the forging of an associa-
tion in the consumer's mind between a generic product like soap,
facial tissue, or romantic fiction and the company name through
the mediation of a deliberately created image." Running against
the trend toward more explicit treatment of sex and greater
emphasis on violence, Harlequin was able to identify and devel-
op this traditional audience. These readers bought the Harlequin
name rather than any one title or author, secure in the knowl-
edge that Harlequin, as Heisey put it, "would be reluctant to pub-
lish anything that might not live up to their expectations." The

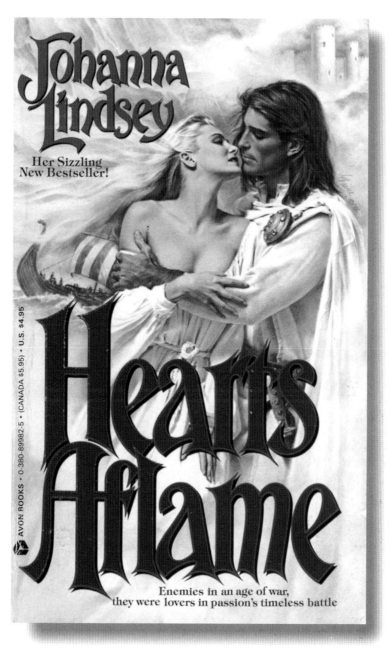

ONE OF MALE COVER model Fabio's early
romance covers was Johanna Lindsey's
1987 historical novel *Hearts Aflame*. By
the early 1990s he had appeared on three
hundred romance covers.

covers, too, changed little. The aim of cover art was to project, according to Heisey, "a quality of innocence."[11] Avon, one of the larger romance houses, established close ties with its readers by compiling a mailing list from its fan letters.

As romances became bigger and bigger business, marketing departments—and not illustrators and art directors—began to determine the look of their covers. For the most part, sex equaled sales, so conveying some idea of a book's story line quickly became less important than advertising some form of distilled passion—hence "the clinch" popularized by *The Flame and the Flower*. The male model took center stage; illustrated images took up a smaller portion of the front cover, leaving backgrounds of a solid color. Big, gaudy script became popular and was soon exclusively associated with romance fiction. The new poster style made illustrations less important than typography or cover-stock hue. Photographs also appeared more often, as well as greeting card–style design practices such as the use of gold seals, embossing, foil stamping, and die cutting.

More than any other gimmick, however, it was the strapping male model with the "bodice-ripping" tendencies that effected the greatest change in the art of the romance novel. In the 1980s, cover model Fabio became a worldwide celebrity—and regular target of late-night comedians—thanks to his bulging pectorals, flowing blond hair, and bedroom eyes. For years to come, the aggressive, primal presence of Fabio and his ilk became the de facto iconography of the romance novel. While women loved these bare-chested hunks, and book sales reflected their devotion, the new covers left little, if anything, to the reader's imagination, and often told nothing of the story inside.

 While these new beefcake covers lacked the character of
earlier romance-novel art, their emphasis on the male body is
probably best understood as a positive reflection of a more equi-
table role for women in contemporary society. After decades of
watching their own bodies salaciously depicted on smutty paper-
back covers geared to male readers—and just about everywhere
else—the overwhelming success of the romance novel gave
women the power and the means to put whomever they wished
on their reading material. Finally the man was the sex object.
And given the subject matter, is it any surprise that women, too,
preferred beauty over brains?

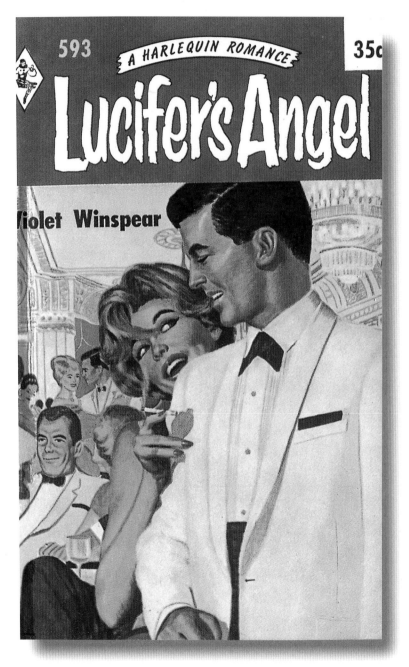

A DAPPER SUITOR in the style of Ian
Fleming's James Bond graces the cover
of *Lucifer's Angel* (Harlequin, 1961).

Notes

1. Janice A. Radway, *Reading the Romance: Women, Patriarchy, and Popular Literature* (Chapel Hill, NC: University of North Carolina Press, 1984), 27.

2. Katharine Brush, *Young Man of Manhattan* (New York: Avon Publishing Co., 1949).

3. Thomas L. Bonn, *UnderCover: An Illustrated History of American Mass Market Paperbacks* (New York: Penguin Books, 1982), 101.

4. Marsha Zinberg, *The Art of Romance: A Century of Romance Art* (Don Mills, Ontario: Harlequin, 1999), 4.

5. Joyce Dingwell, *Corporation Boss* (Toronto: Harlequin Books, 1975).

6. Carol Thurston, *The Romance Revolution* (Chicago: University of Illinois Press, 1987).

7. John Tebbel, in foreword to Bonn, *UnderCover*, 10.

8. Caesarea Abartis, "The Ugly-Pretty, Dull-Bright, Weak-Strong Girl in the Gothic Mansion," *Journal of Popular Culture* 13 (fall 1979); Marian Starr, "Sweet-Savage Book: The Romance in America, 1855–1980," (n.p., 1981); Elizabeth Jolley, "The House of Love: Passion's Fortune: The Story of Mills & Boon by Joseph McAleer," *The Age*, 6 March 2000.

9. Linda Barlow and Jayne Ann Krentz, quoted in Paul Gray and Andrea Sachs, "Passion on the Pages," *Time*, 20 March 2000.

10. Radway, *Reading the Romance*, 27.

11. W. Lawrence Heisey, quoted in Radway, *Reading the Romance*, 39–41.

Happily Ever After

The arc of the traditional romance relationship follows a simple pattern: woman desires man, man is hard to get, woman snags man, they live happily ever after. Marriage is nearly always the ultimate goal, and the stories always end happily. These are tales of first love, true love, and lasting love—but not passionate love. In contrast to steamier romances, the covers for such classic romances feature attractive, well-groomed couples behaving themselves decorously. They may embrace, hold hands, or stare into each other's eyes, but they never move on to anything scandalous.

Bride romances, which tap into generations of women's neuroses over finding the right man—or any man—have always been popular. Covers for these stories usually feature a story book bride, in white, of course. But not all relationships last forever, so romance novels also explore the heartache of matrimonial trouble by way of adulterous affairs, love triangles, and divorce. Pony Books billed Kathleen Norris's 1946 novel *Second Hand Wife* as a "poignant, dramatic story of love, marriage, and divorce."

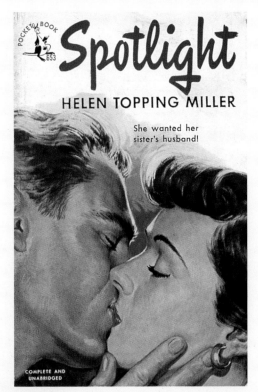

SPOTLIGHT
Helen Topping Miller
Pocket Books, 1950
Cover illustration by Victor Kalin

ASPECTS OF LOVE
David Garnett
Dell Books, 1957
Cover illustration by Reynold Ruffins

THE WHOLE HEART
Helen Howe
Avon Books, 1943

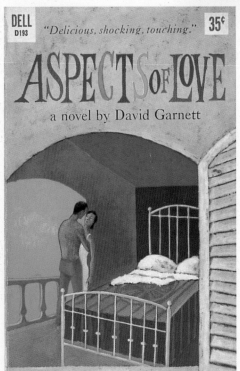

Illustrators often created their covers from a rough sketch provided by the art director. The illustrator allowed a specified space in the design for the type. Once the illustration was complete the type was added using overlays.

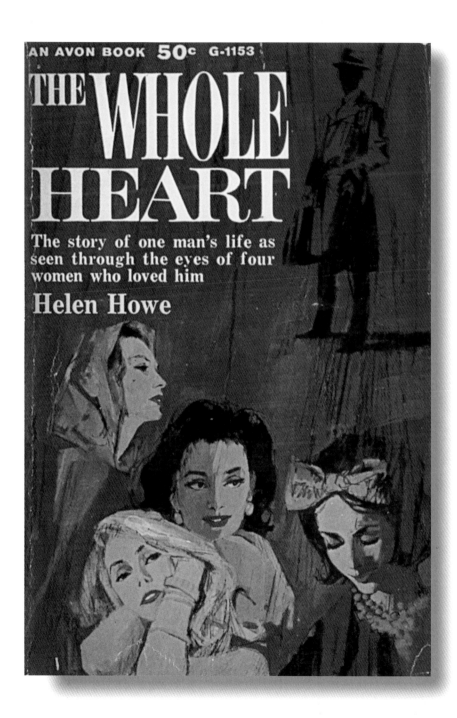

AN AVON BOOK 50ᶜ G-1153

THE WHOLE HEART

The story of one man's life as seen through the eyes of four women who loved him

Helen Howe

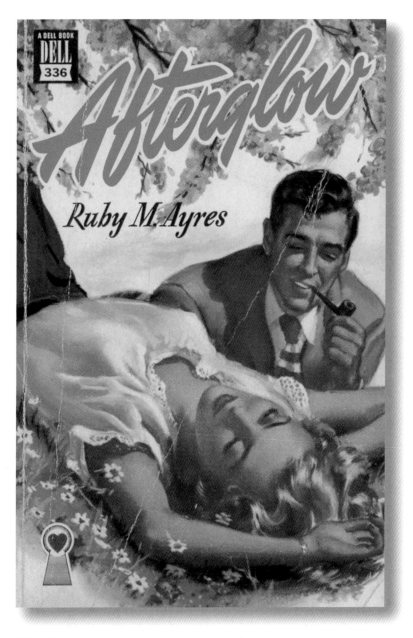

Afterglow features a
romance-cover cliché: the
heroine lies on the ground
with her eyes closed and her
lover looming above her.

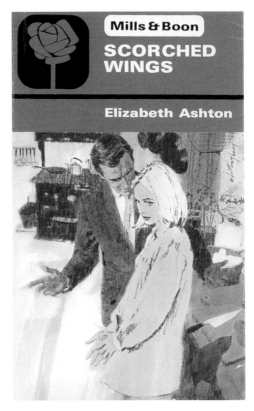

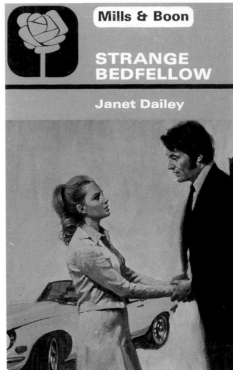

AFTERGLOW
Ruby M. Ayres
Dell Books, 1936
Cover illustration by
William George Jacobson

SCORCHED WINGS
Elizabeth Ashton
Mills & Boon, 1972

STRANGE BEDFELLOW
Janet Dailey
Mills & Boon, no date.

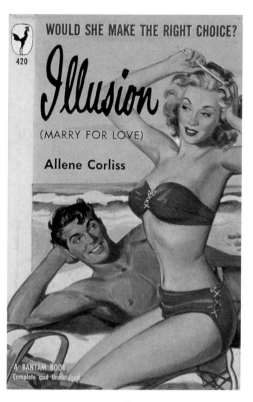

The early romance covers seldom featured men and women kissing. Gazing, embracing, and almost kissing were acceptable. *Illusion*, like many Bantam Books of the late 1940s, featured a paragraph opposite the title page that summarized an event in the book. This was usually the same summary that was given to the illustrator to help create the cover.

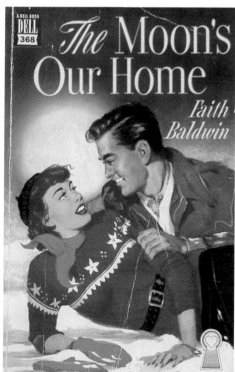

ILLUSION
Allene Corliss
Bantam Books, 1949
Cover illustration by Bert Lannon

THE MOON'S OUR HOME
Faith Baldwin
Dell Books, 1936

YOUNG MAN OF MANHATTAN
Katharine Brush
Avon Books, 1949

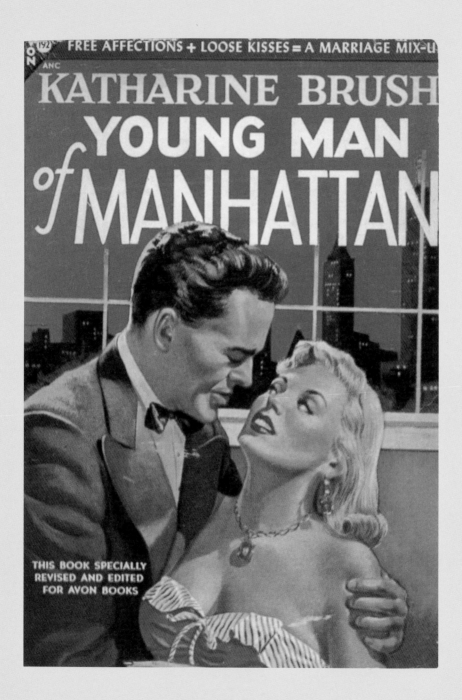

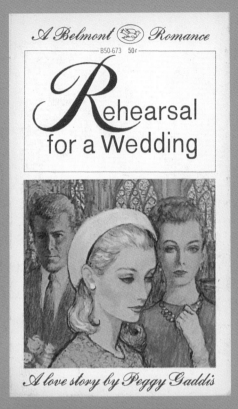

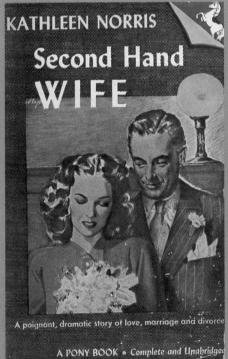

REHEARSAL FOR A WEDDING
Peggy Gaddis
Belmont Books, 1966

SECOND HAND WIFE
Kathleen Norris
Pony Books, 1946

EVER AFTER
Phyllis Whitney
Lancer Books, 1966

LANCER BOOKS ◆72-131◆50¢

SHE WAS DETERMINED TO BE A SUCCESS—
IN HER CAREER AND HER MARRIAGE...
"ABSORBING, EXCELLENT"—*Chicago Tribune*

Phyllis Whitney
Ever After

A BOOK FOR YOUNG PEOPLE
by the best-selling author of "COLUMBELLA"

A Belmont 🕊 Romance

B50-684 50¢

Wedding Song

A love story by Peggy Gaddis

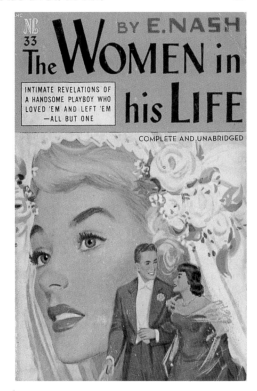

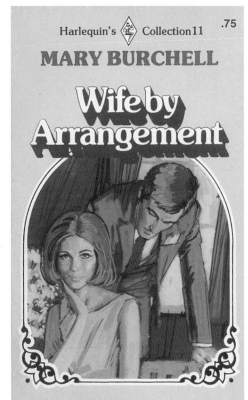

WEDDING SONG
Peggy Gaddis
Belmont Books, 1966

THE WOMEN IN HIS LIFE
E. Nash
Novel Library, 1950

WIFE BY ARRANGEMENT
Mary Burchell
Harlequin Books, 1976

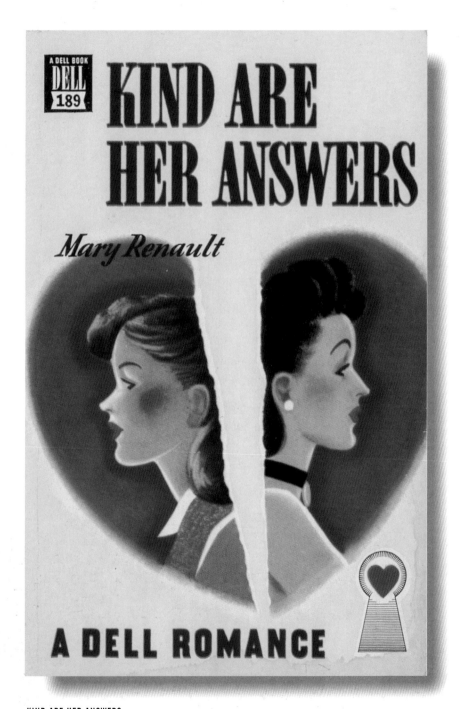

KIND ARE HER ANSWERS
Mary Renault
Dell Books, 1940

KIND ARE HER ANSWERS

What this *Love Story* is about—

Kit Anderson is resolved never to be emotionally bound by a woman again. His marriage to cold, selfish Janet has just ended in his heart, a little to his own surprise, and he is exulting in a new sense of release. A coming young doctor in a small English town, he is free now to devote himself wholly to his work.

Then, in the home of her invalid aunt, he meets Christie Heath, warm-hearted and unconventional, and is strangely attracted by her. They are scarcely acquainted when Christie, without seeming to move, is in his arms. *This is madness,* thinks Kit, but he only clasps her more tightly. And when she invites him to her room, he goes.

His marriage to Janet ended physically a year ago, when Janet bore a dead child and nearly died herself. There are to be no more children, and the knowledge that Janet does not want him as a husband but only as a sort of screen between herself and the actualities of life has tinged Kit's life with a sense of frustration.

Now, as his hunger for Christie grows, there is a shift in his frustration. Since his profession, in England, frowns on divorce, he must take his stolen hours with Christie whenever and wherever he can, always fully aware of the disaster which will result from discovery. He can almost see the notice in the *Medical Journal: While visiting the house of a patient in a medical capacity* . . .

Their first intimation of catastrophe, and of how their lives are to be shaped, comes to Kit and Christie the night of old Miss Heath's death. . . .

The people in this voluptuous, beautifully written, and provocative novel are as real as yesterday and tomorrow. It is the work of the brilliant young English author whose "Return to Night" won the glamorous Metro-Goldwyn-Mayer $150,000 prize.

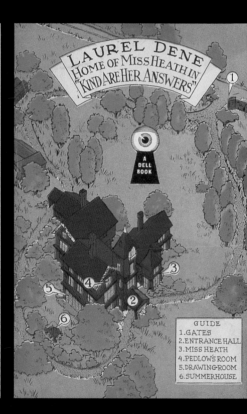

An example of a Dell mapback, *Kind Are her Answers* features a map on the back cover depicting a principal scene from the story. Mapbacks are now highly sought after by collectors.

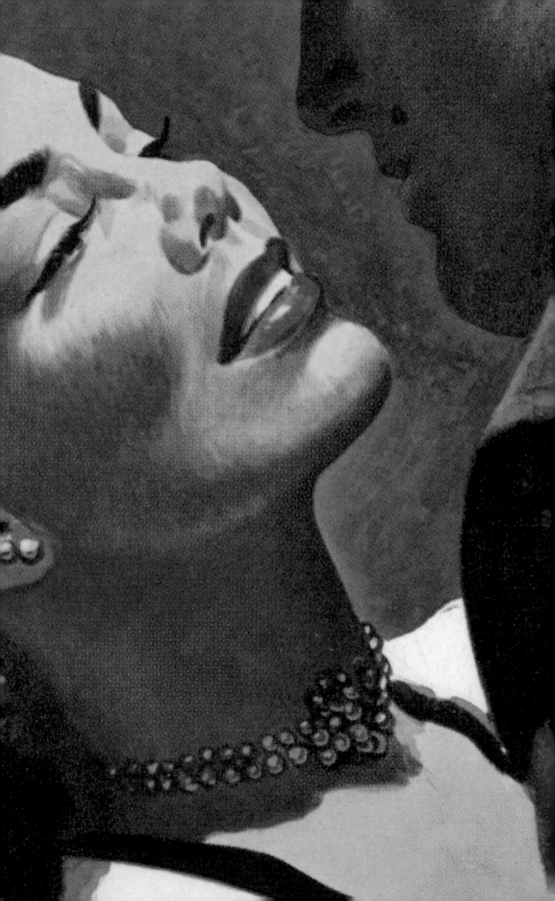

Passions Aflame

I n contrast to the sweet covers of traditional romance stories, those of more passionate tales feature a little more skin and a lot more sexual innuendo. Instead of standing and embracing, the lovers twist on the ground, overcome by their lust. Denys Val Baker's 1956 *A Journey with Love* features a couple having a go at it on the beach à la *From Here to Eternity* (the racy cover illustration was by Baryé Phillips). "Martin was an artist, Lesley an actress," wrote Baker. "Convention could not keep them from each other's arms. Together they explored the world of sense and feeling—rapturously, completely." A newspaper excerpt on the cover billed prose as explicit as in D. H. Lawrence's 1928 *Lady Chatterley's Lover*—a benchmark for blue writing.

By the 1970s, clothing was growing more and more scarce. The disrobing only could signify pure passion. Such was the case with Mason, the bare-chested hero posed on the cover of Casey Brent's 1979 novel *Moonflower*: "Hallie kept a cool distance, knowing too well how Mason's touch could send her senses reeling. Why was her very soul drawn to Mason's fire, she wondered, when every instinct warned her of sorrow?"

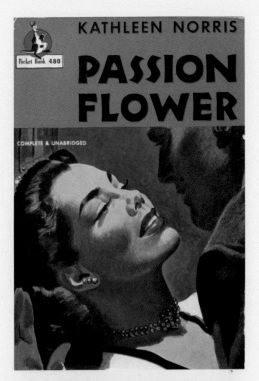

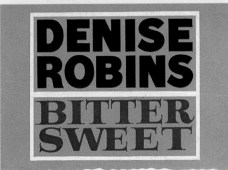

PASSIONFLOWER
Kathleen Norris
Pocket Books, 1947

BITTERSWEET
Denise Robins
Arrow Books, 1965

THE RESTLESS PASSION
Viña Delmar
Avon Books, 1947

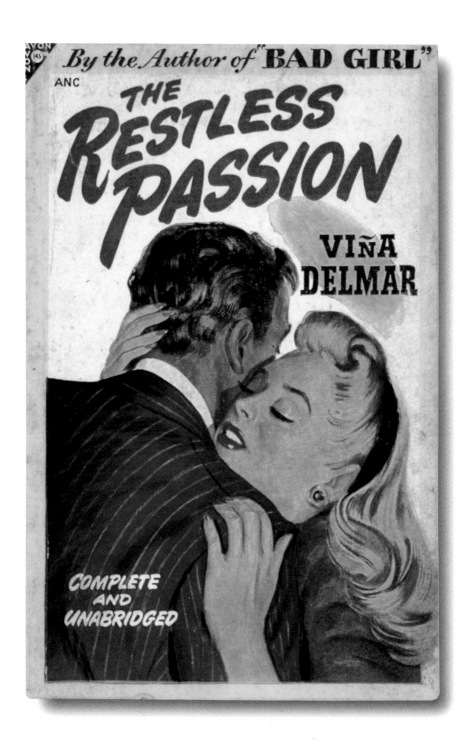

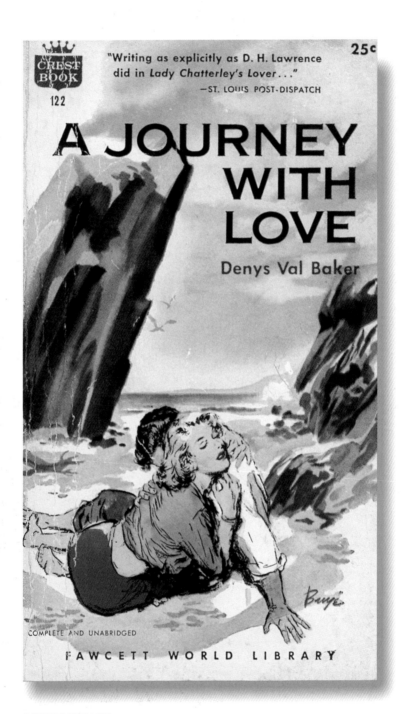

A JOURNEY WITH LOVE
Denys Val Baker
Fawcett World Library, 1956
Cover illustration by Baryé
Phillips

CREST BOOK

Convention meant nothing to them...

Martin was an artist, Lesley an actress. Convention could not keep them from each other's arms. Together they explored the world of sense and feeling —rapturously, completely.

Then something happened that threatened to destroy utterly their almost perfect relationship. For Martin the disaster made a mockery of their life together.

But Lesley, with a woman's faith, was sure so great a love as theirs could triumph over the most brutal of facts.

Ahead of them lay the testing—and hope, or despair.

FAWCETT WORLD LIBRARY

A JOURNEY WITH LOVE

This Fawcett cover was illustrated by Baryé Phillips, who was known as "The King of the Paperbacks" due to his speed at turning out covers and his ability to work in a variety of styles.

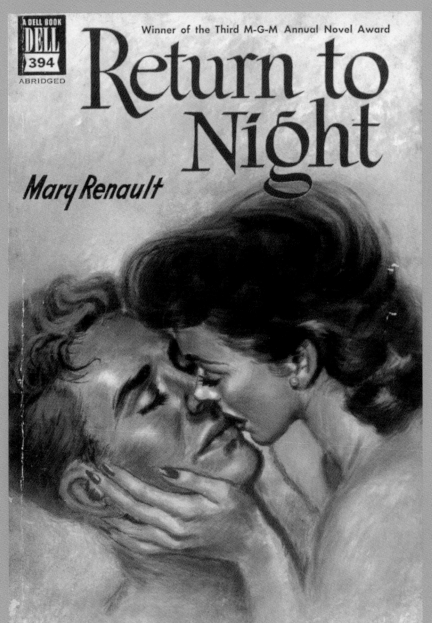

A DELL BOOK

DELL
394
ABRIDGED

Winner of the Third M-G-M Annual Novel Award

Return to Night

Mary Renault

Magnetic, keenly intuitive in her career as a doctor, she alone could challenge the sinister force destroying the man she loved.

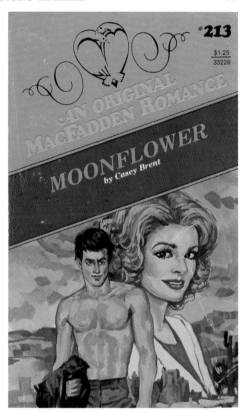

A bare chest! Quite
common today, but
prior to the 1980s
they were rare.

RETURN TO NIGHT
Mary Renault
Dell Books, 1947
Cover illustration by Bill Gregg

MOONFLOWER
Casey Brent
MacFadden Books, 1979

TO LOVE BY CANDLELIGHT
Philip Lindsay
Avon Books, no date

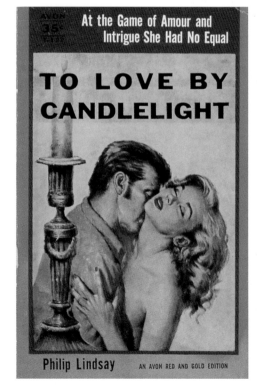

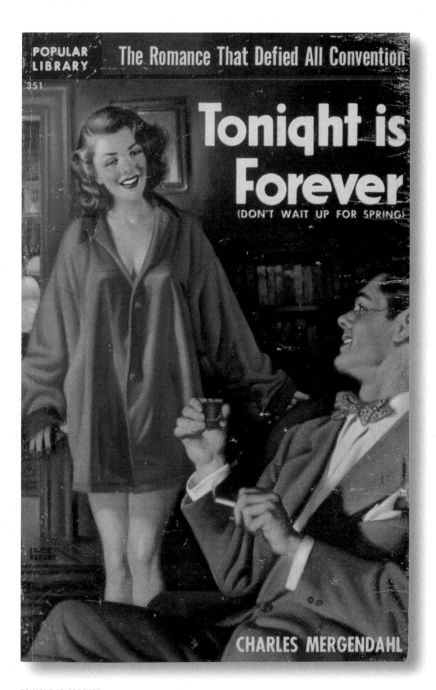

TONIGHT IS FOREVER
Charles Mergendahl
Popular Library, 1951
Cover illustration by Earle Bergey

"I'm COMING HOME
with you darling!"

It was a bombshell proposal from a girl he
barely knew. Harry Trexler stared across the
cafeteria table at lovely Barbara Gray.
"I've watched you at rehearsals," she said.
"I like the way you wrinkle your nose.
Besides, you're very attractive and I'm going
to marry you." There was a silence. Then
she said a wonderful thing. "I'm going
to follow you wherever you go"
So began a whirlwind romance between a New
York playright and the glamorous leading
lady of his play. It was a romance that
had to end in three weeks when Harry
would be drafted—a romance that defied all
conventions as they crowded every hour
with their feverish love.

Woman on Her Way

I t's a decision women have been grappling with for decades: a career or a man? While now many women can and do have both, or at least think they do, before the equal rights movement there was only one accepted road to happiness and security: marriage. Both in the real world and on the pages of romance novels there were but a few daring and independent women willing to take the career path exclusively. In 1932's *Self-Made Woman* the heroine was "a smashing success, but she had had no time for love." The "problem" of love getting in the way of career befell romance heroines of all professions, from secretaries to surgeons. In *Ann Kenyon: Surgeon* of 1950, author Adeline McElfresh writes: "To be in love, to be in doubt, to fight the turmoil of emotion that rose within her, clouding her mind even as she held a scalpel in her hands."

These career covers usually feature the heroine surrounded by the accoutrements of her profession, as with *The Doctor Is a Lady* of 1959. The cover of 1931's *Skyscraper* features an impressive office tower that looms in the background as the heroine contemplates her future: "Life stretches out excitingly for pretty and ambitious young Lynn Harding. She doesn't have time for marriage—yet."

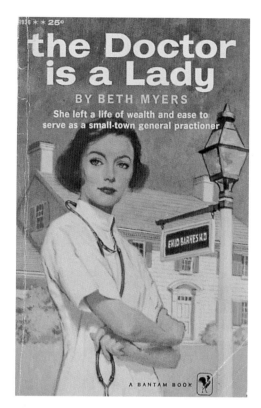

Sometimes models were photographed in different poses, allowing the illustrator to create a variety of images.

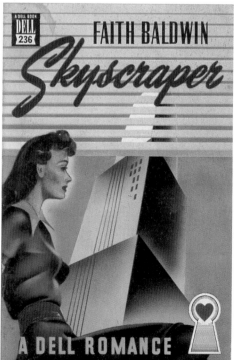

THE DOCTOR IS A LADY
Beth Myers
Bantam Books, 1959

SKYSCRAPER
Faith Baldwin
Dell Books, 1931

SELF-MADE WOMAN
Faith Baldwin
Dell Books, 1932

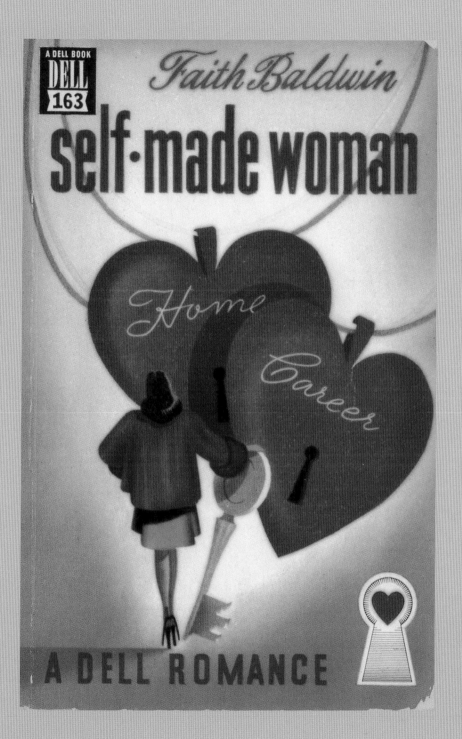

"IS THAT THE DOCTOR?"

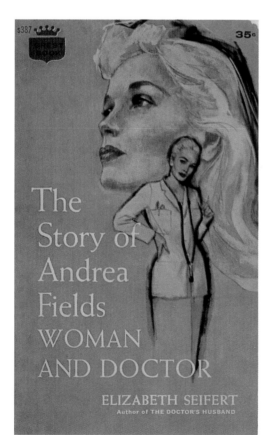

THE STORY OF ANDREA FIELDS: WOMAN AND DOCTOR
Elizabeth Seifert
Fawcett World Library, 1960

ANN KENYON: SURGEON
Adeline McElfresh
Dell Books, 1950
Cover illustration by Bob Abbett

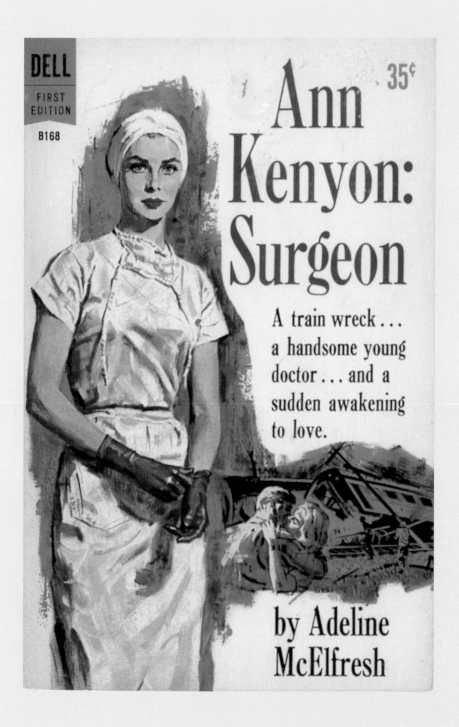

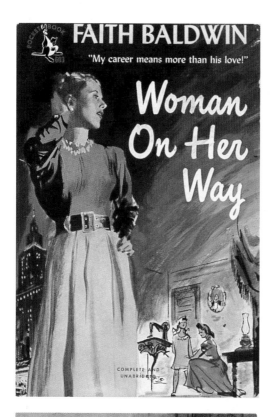

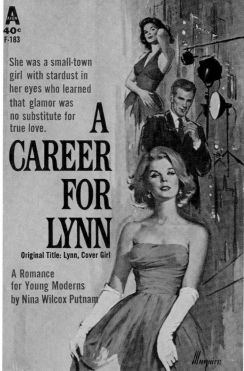

WOMAN ON HER WAY
Faith Baldwin
Pocket Books, 1949
Cover illustration by Baryé Phillips

A CAREER FOR LYNN
Nina Wilcox Putnam
Avon Books, 1950
Cover illustration by Robert Maguire

BRIEF GOLDEN TIME
Marjorie Vernon
Paperback Library, 1966

BRIEF GOLDEN TIME

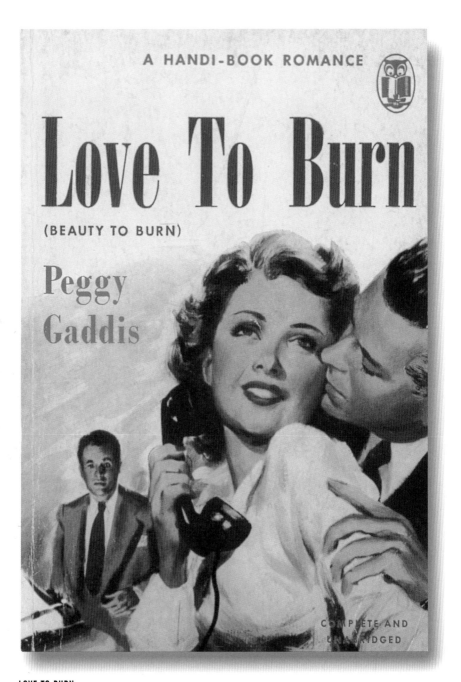

LOVE TO BURN
Peggy Gaddis
Handi-Book Editions, 1949

CORPORATION BOSS
Joyce Dingwell
Harlequin Books, 1975

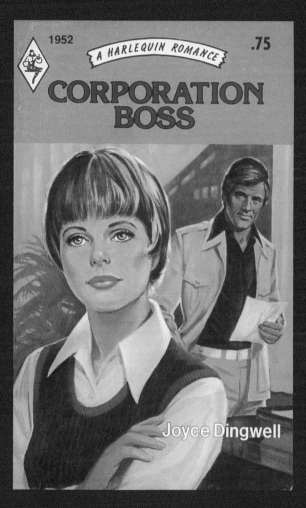

1952 *A HARLEQUIN ROMANCE* .75

CORPORATION BOSS

Joyce Dingwell

Harlequin retained its simple covers,
which projected a quality of sweet innocence,
well into the 1970s. The illustration for
Corporation Boss, while featuring an
ostensibly modern woman in modern clothing,
is in much the same style as its covers from
the 1950s (see pages 88-89).

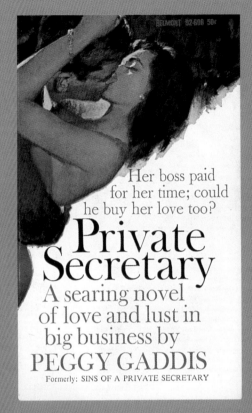

Her boss paid
for her time; could
he buy her love too?

Private Secretary

A searing novel
of love and lust in
big business by
PEGGY GADDIS
Formerly: SINS OF A PRIVATE SECRETARY

Mills & Boon 1020

THE TENDER NIGHT

Lilian Peake

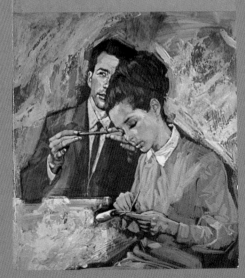

PRIVATE SECRETARY
Peggy Gaddis
Belmont Books, 1964

THE TENDER NIGHT
Lilian Peake
Mills & Boon, 1975

OFFICE LOVE AFFAIR
Peggy Gaddis
Belmont Books, 1965

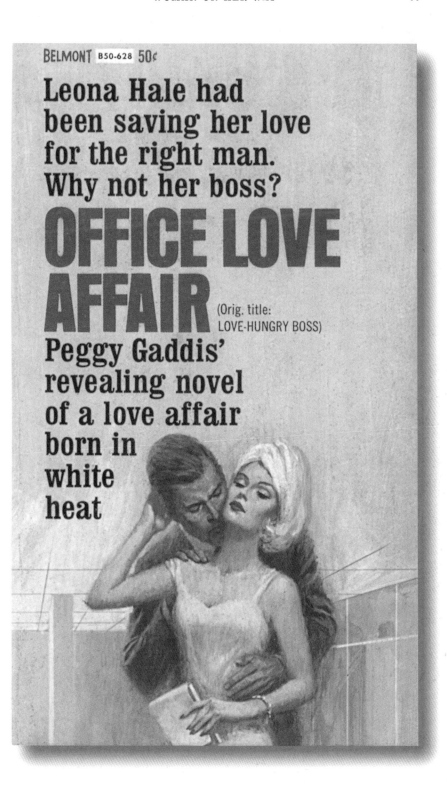

BELMONT B50-628 50¢

Leona Hale had
been saving her love
for the right man.
Why not her boss?

OFFICE LOVE AFFAIR

(Orig. title:
LOVE-HUNGRY BOSS)

Peggy Gaddis'
revealing novel
of a love affair
born in
white
heat

Bad Girls & Good Girls

The bad girl. On romance covers she's the one with the cleavage, the short skirt, or the wild look in her eye. Sometimes the title says it all: *The Abortive Hussy, The Hard-Boiled Virgin, Call Her Savage.* "There's one in every town, a girl from the wrong side of the tracks who'd do ANYTHING for money," wrote Barbara Brooks of the lusty "heroine" of *Hellcat*.

On the other side of the tracks are the good girls: the prim and saccharin-sweet heroines of such stories as *Fair Stranger* and *Once upon a Summer.* The innocence of the title character in Marcia Ford's 1961 *Linda's Champion Cocker* is exemplary: "Princess Patricia had all the characteristics of a champion, and Linda felt that it was only a matter of time before the beautiful blonde cocker won a blue ribbon." But even good girls find themselves in bad relationships, as in Margaret Pedler's *The Barbarian Lover* of 1959. In these stories, the heroine must find the strength to tame a dangerous man. And then there are the all-around dangerous relationships in which the heroine must prevail against not a domineering man, but an unforgiving society, as in Cid Ricketts Sumner's 1947 *Quality*: "She passed for white but she found love and happiness among her negro friends."

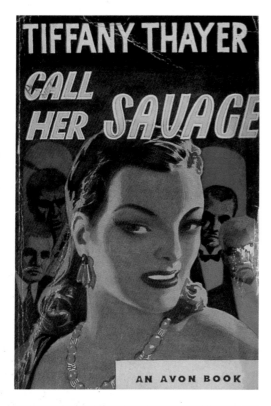

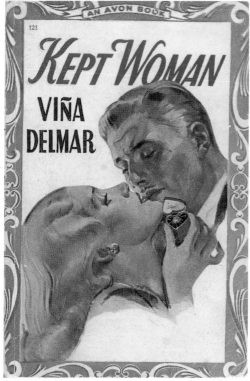

CALL HER SAVAGE
Tiffany Thayer
Avon Books, 1931

KEPT WOMAN
Viña Delmar
Avon Books, 1947

A ROOM IN PARIS
Peggy Mann
Popular Library, 1956
Cover illustration by Mitchell Hooks

A Frank And Moving Novel Of Young Love

G167

35c

A ROOM IN PARIS

PEGGY MANN

COMPLETE AND
UNABRIDGED

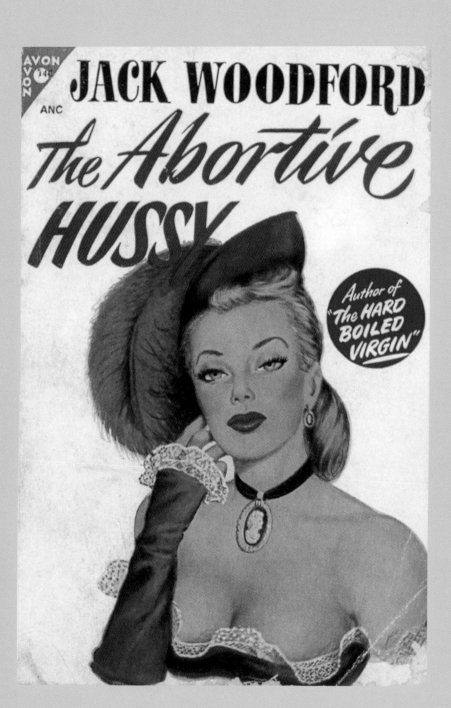

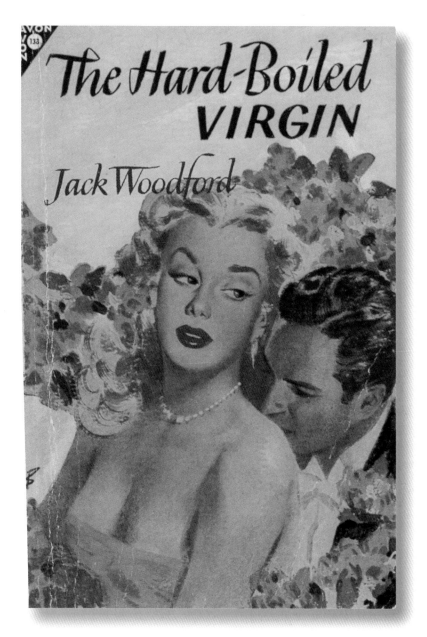

THE ABORTIVE HUSSY
Jack Woodford
Avon Books, 1947

THE HARD-BOILED VIRGIN
Jack Woodford
Avon Books, 1947

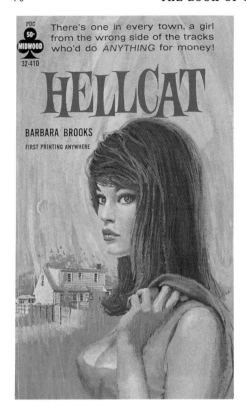

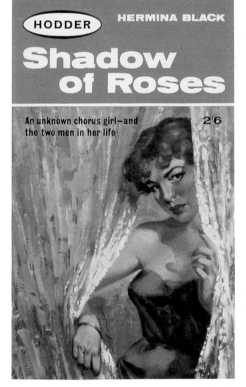

HELLCAT
Barbara Brooks
Midwood, 1964

SHADOW OF ROSES
Hermina Black
Hodder and Stoughton, 1963

Patty Corliss fainted at Richard Ballard's feet—and the unknown chorus girl was on her way to stardom

But love and heartbreak lay in wait for Patty, for the man she worshipped and for the other man who worshipped her

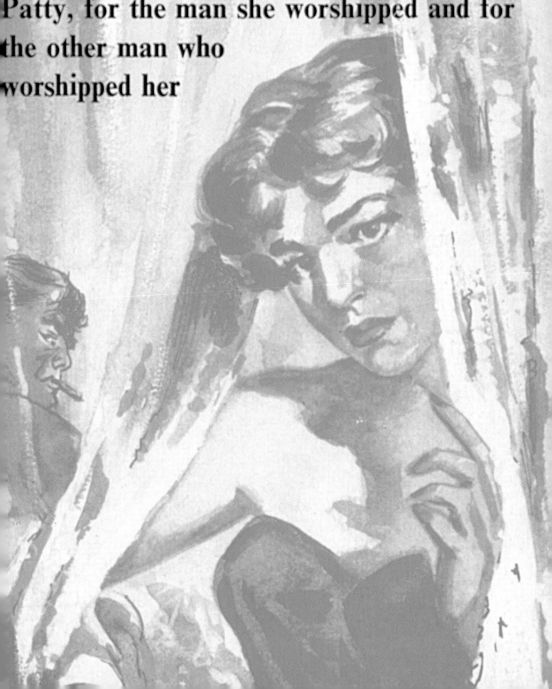

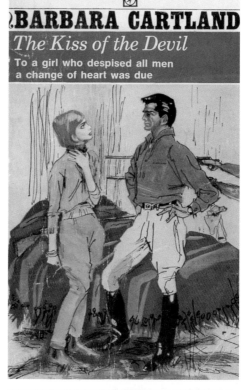

Known as "The Queen of Romance," Barbara Cartland (1901–2000), who was also step-grand-mother to Princess Diana, wrote more than seven hundred romance novels. Her books have been translated into thirty-six languages.

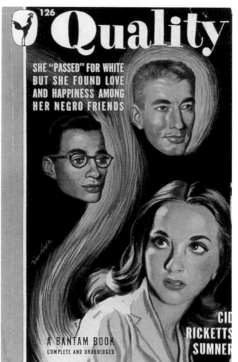

THE BARBARIAN LOVER
Margaret Pedler
Hodder and Stoughton, 1959

THE KISS OF THE DEVIL
Barbara Cartland
Arrow Books, 1961

QUALITY
Cid Ricketts Sumner
Bantam Books, 1947
Cover illustration by Bernard D'Andrea

Mills & Boon

Romance

FIRST LOVE, LAST LOVE

Carole Mortimer

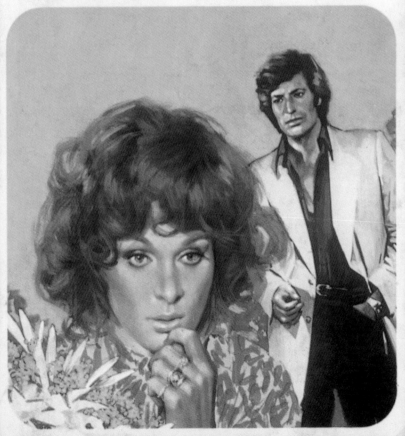

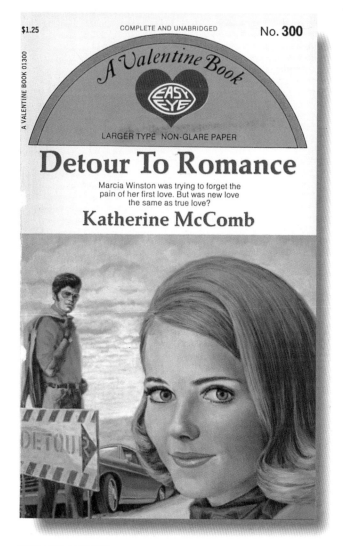

FIRST LOVE, LAST LOVE
Carole Mortimer
Mills & Boon, 1981

DETOUR TO ROMANCE
Katherine McComb
Valentine Books, 1969

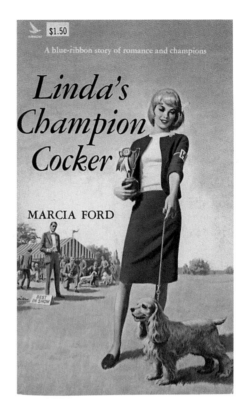

In wholesome stories like
Linda's Champion Cocker,
love scenes are not graphi-
cally described—though
there is no shortage of
innuendo.

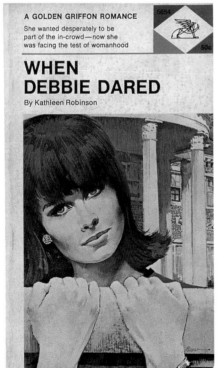

LINDA'S CHAMPION COCKER
Marcia Ford
Airmont Books, 1961

WHEN DEBBIE DARED
Kathleen Robinson
Golden Press, 1963
Cover illustration by Ron Lesser

ONCE UPON A SUMMER
Natalie Shipman
Airmont Books, 1963

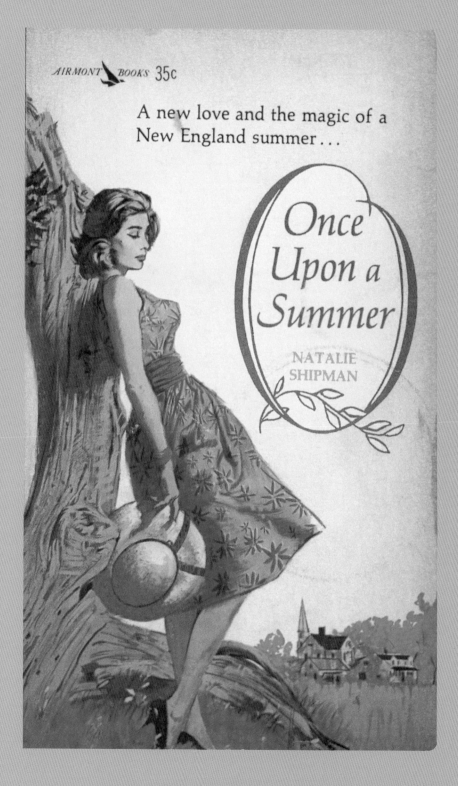

AIRMONT BOOKS 35c

A new love and the magic of a
New England summer...

Once
Upon a
Summer

NATALIE
SHIPMAN

46

Blonde over bride

Fair Stranger

CECILE GILMORE

CY HEAL

A
HARLEQUIN
BOOK

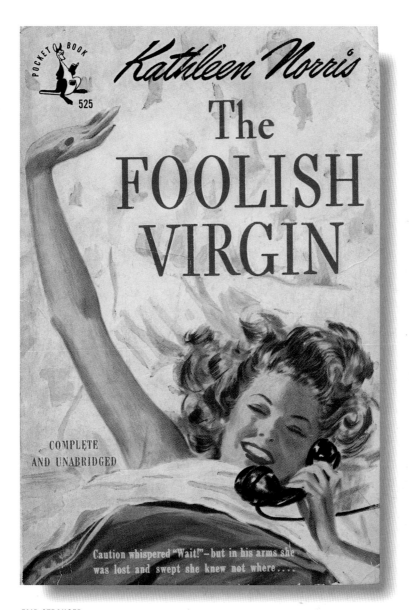

FAIR STRANGER
Cecile Gilmore
Harlequin Books, 1950
Cover illustration by Cy Heal

THE FOOLISH VIRGIN
Kathleen Norris
Pocket Books, 1948
Cover illustration by Baryé Phillips

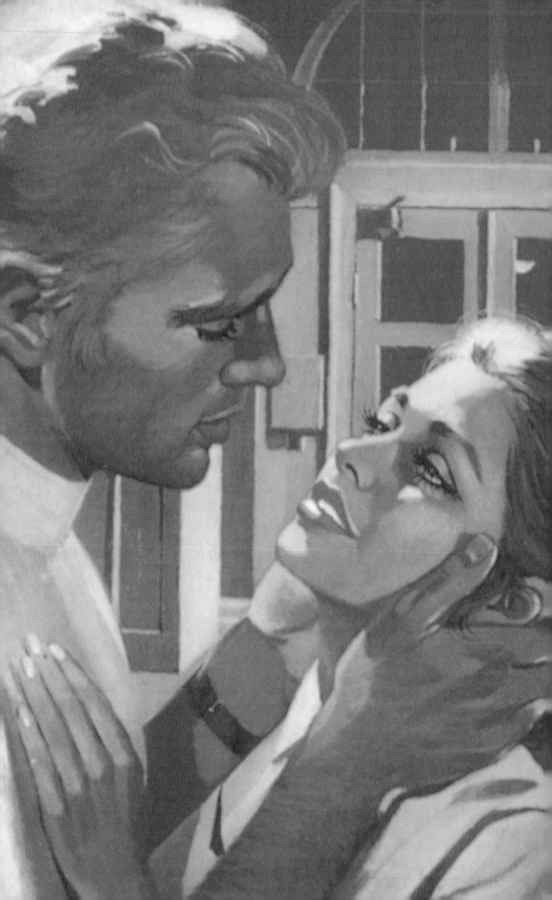

Loves of a Nurse

A longtime heroine of romance novels, by the late 1960s the nurse was everywhere—from the neighborhood clinic to the African jungle. Whether a *Camp Nurse* or a *Society Nurse*, she represented to millions of readers the independent, hard working, daring women they thought they were or wanted to be. As in the career vs. man romances, the nurse heroine often must choose between a man and job. In 1948's *Nurse into Woman*, she even goes so far as to renounce her gender. "'I'm a nurse, not a woman,' said Kristine. 'I've resolved never to marry—never to have a child. I'm a good nurse— I'll stay one. I'm not going to be a woman.'" In Diana Douglas's 1973 *Beauty Contest Nurse* it's the same story: "When tawny-eyed nurse Maria MacKenzie sought to escape the routine and regimentation of the Veterans' Hospital, she never expected anything like her job at a luxurious resort hotel in Acapulco. . . . Maria soon discovered that her feminine attributes as a lovely young woman were more important than her nursing skill." The nurse character's dedication to her job often gets in the way of love, but in the end she is usually able to juggle both.

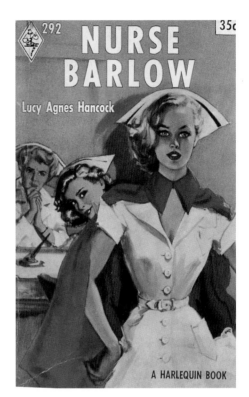

The early Harlequin covers featured full-bleed illustrations, such as the ones for *Nurse Barlow* and *General Duty Nurse.*

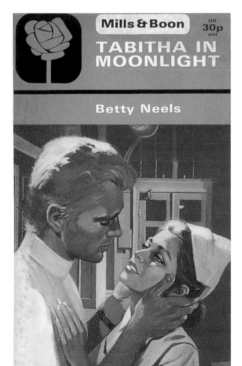

NURSE BARLOW
Lucy Agnes Hancock
Harlequin Books, 1956

TABITHA IN MOONLIGHT
Betty Neels
Mills & Boon, 1972

GENERAL DUTY NURSE
Lucy Agnes Hancock
Harlequin Books, 1953

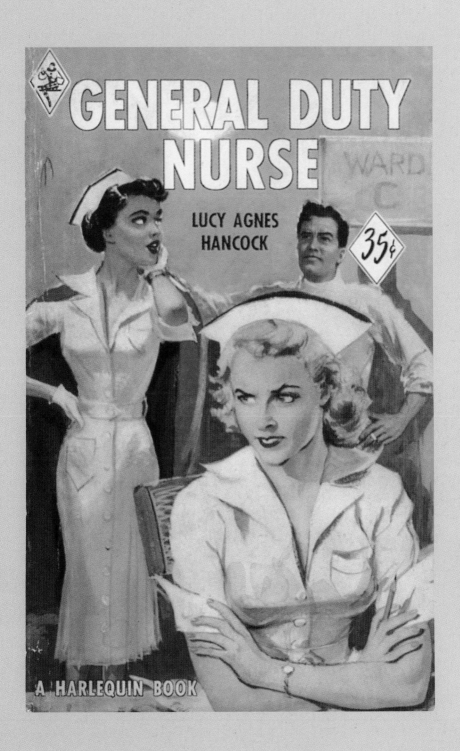

GENERAL DUTY NURSE

LUCY AGNES HANCOCK

35¢

A HARLEQUIN BOOK

Hootenanny Nurse

Julie Dodd was in love with David Stace, the boy next door, ever since she could remember. When he studied to become a doctor, Julie decided that nursing would be her career so that their work would bring them together. And that is exactly what happened. Then Chad, a handsome folk singer, came into her life, and suddenly there was a new song in her heart.

HOOTENANNY NURSE
Suzanne Roberts
Ace Books, 1964

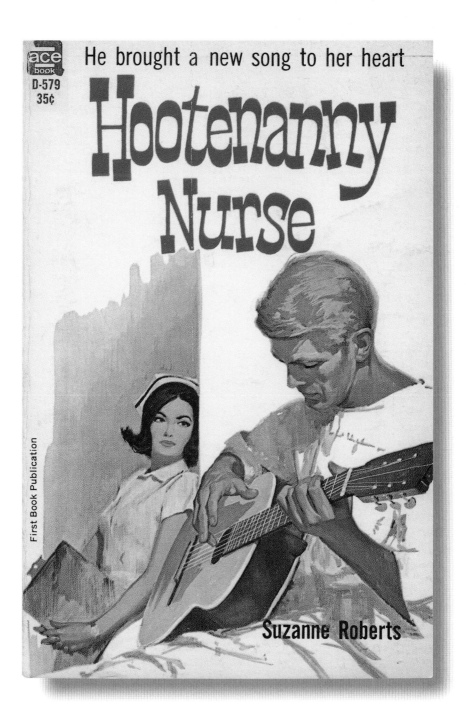

ace book

D-579
35¢

First Book Publication

He brought a new song to her heart

Hootenanny Nurse

Suzanne Roberts

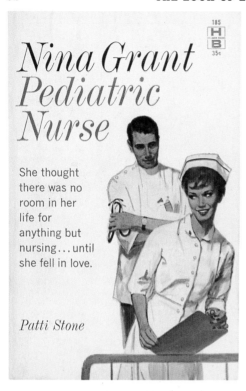

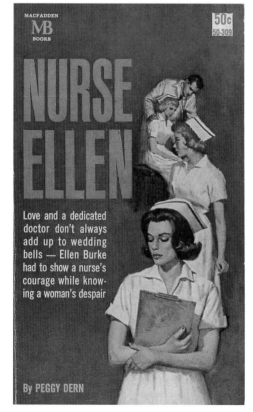

NINA GRANT: PEDIATRIC NURSE
Patti Stone
Hillman Books, 1961

NURSE ELLEN
Peggy Dern
MacFadden Books, 1956

NURSE ON THE RUN
Arlene Hale
Ace Books, 1965

AN ACE BOOK | 59776 | **60¢**

Ace Nurse Romance Series

READ EASY LARGE TYPE

NURSE ON THE RUN
by Arlene Hale

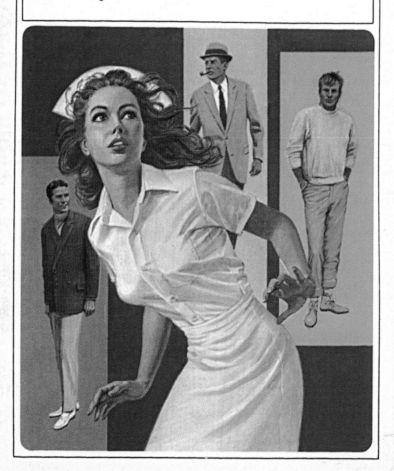

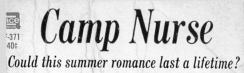

Camp Nurse

Could this summer romance last a lifetime?

Arlene Hale

First Book Publication

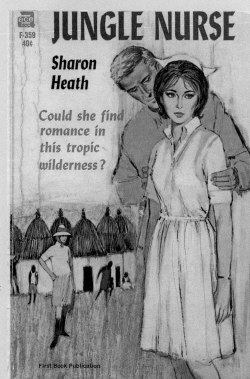

JUNGLE NURSE

F-359
40¢

Sharon Heath

Could she find romance in this tropic wilderness?

First Book Publication

EVERGLADES NURSE
Peggy Gaddis
MacFadden Books, 1965

CAMP NURSE
Arlene Hale
Ace Books, 1966

JUNGLE NURSE
Sharon Heath
Ace Books, 1965

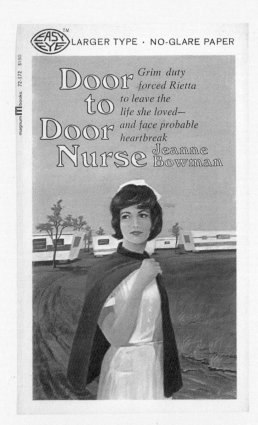

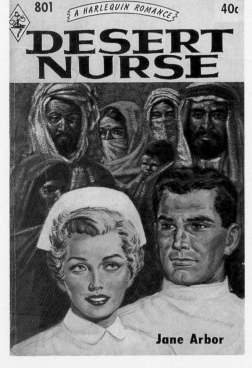

DOOR TO DOOR NURSE
Jeanne Bowman
Magnum Books, 1967

DESERT NURSE
Jane Arbor
Harlequin Books, 1964

SETTLEMENT NURSE
Peggy Gaddis
Avon Books, 1959

A
AVON
35¢
T-543

Andrea Drake
finds romance
and rich reward
through her
work as a

SETTLEMENT NURSE

Peggy Gaddis

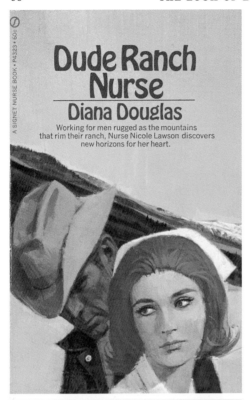

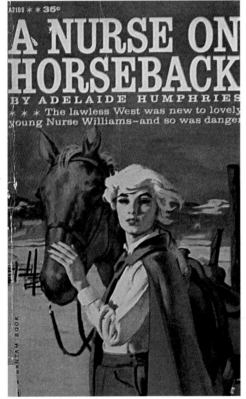

DUDE RANCH NURSE
Diana Douglas
Signet New American
Library, 1970

A NURSE ON HORSEBACK
Adelaide Humphries
Bantam Books, 1960

DUDE RANCH NURSE
Arlene Hale
Ace Books, 1963

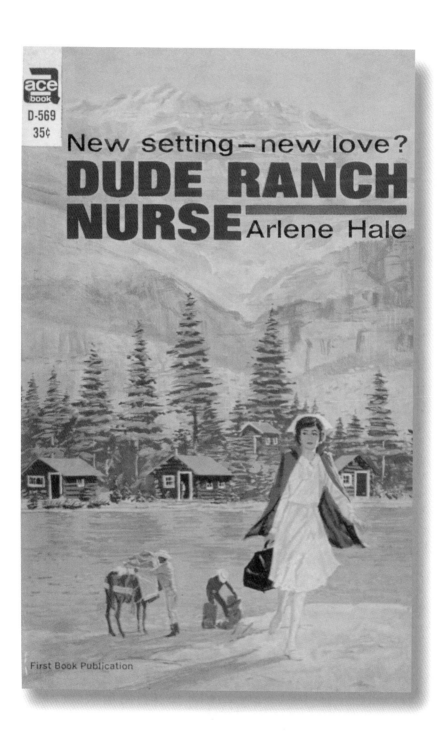

ace book

D-569

35¢

New setting—new love?

DUDE RANCH NURSE

Arlene Hale

First Book Publication

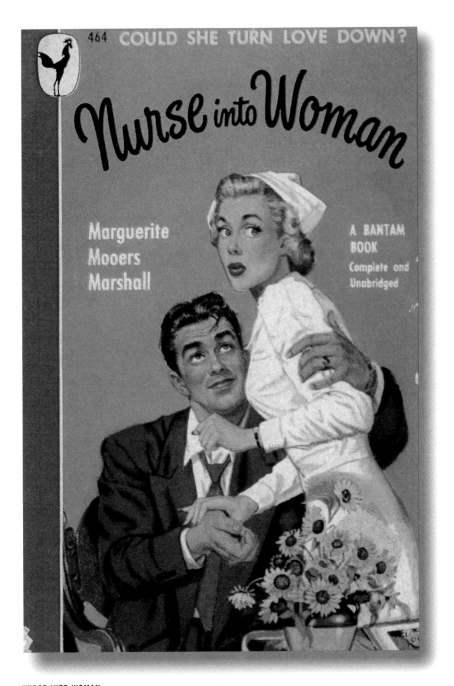

NURSE INTO WOMAN
Marguerite Mooers Marshall
Bantam Books, 1948
Cover illustration by Dave Attie

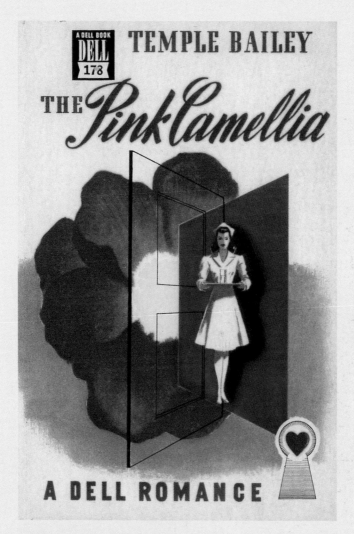

This Dell cover is a good example
of the publisher's early surrealist-
inspired covers. Dell staff artist
Gerald Gregg often used frag-
mented body parts and floating
objects in the style of Salvador
Dalí, which he rendered primarily
with an airbrush.

THE PINK CAMELLIA
Temple Bailey
Dell Books, 1942

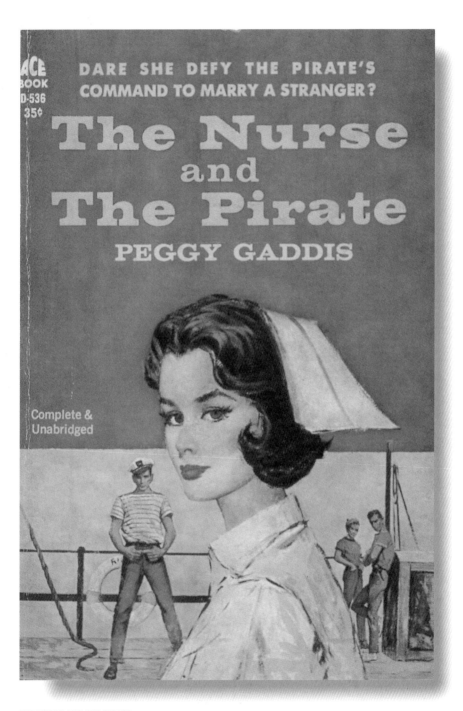

THE NURSE AND THE PIRATE
Peggy Gaddis
Ace Books, 1961

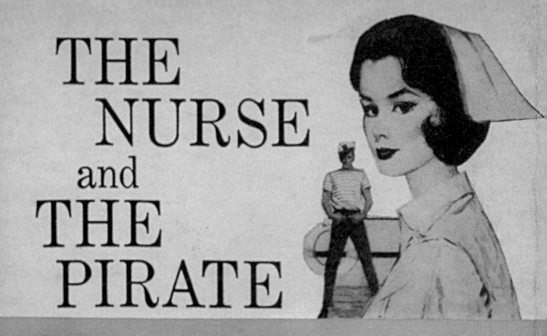

THE NURSE and THE PIRATE

After five months as a cruise nurse on the luxury liner *Santa Theresa*, Kathy was glad that the trip was almost over and that she soon would be back to the demanding atmosphere of a big city hospital.

Suddenly, during a starless tropical night, a desperate band of men seized the liner by force and terrorized the passengers and crew.

All at once Kathy not only had more nursing to do than any one nurse could handle, but she had become the special object of attention of the leader of the pirates!

ace book

D-584
35¢

AIRPORT NURSE

Monica Edwards

Take flight, my heart!

First Book Publication

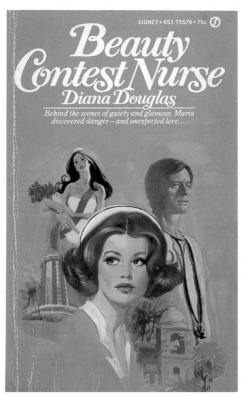

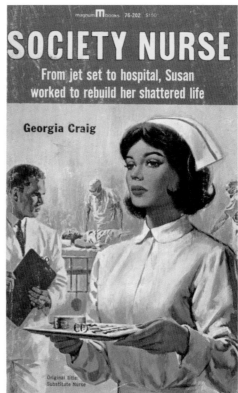

AIRPORT NURSE
Monica Edwards
Ace Books, 1964

BEAUTY CONTEST NURSE
Diana Douglas
Signet New American Library,
1973

SOCIETY NURSE
Georgia Craig
Magnum Books, 1962

Hometown Doctor

T here's a special aura the title "Dr." gives a man. The medical doctor, for many women and romance heroines, not to mention meddlesome mothers, is the ultimate prize and the ideal future. In romance novels he indeed has everything: a professional degree and an athletic physique to go along with it. But his job often gets him into trouble, as in Florence Stonebraker's 1962 *Young Doctor Elliot*: "The story of a young doctor's struggle between emotion and dedication...and what happens when the 'Love Doctor' forgets the code of his own profession." He, and sometimes "she," is torn between duty and love. In Dorothy Worley's 1962 *A Halo for Dr. Michael*, the title character typically finds himself torn between duty and love: "Dr. Michael Brent knew he might be giving up his career as a big-city specialist, and his chance to marry the beautiful and sophisticated Sylvia Denton, when he decided to help out Dr. Wayne in the small town of Burkeville."

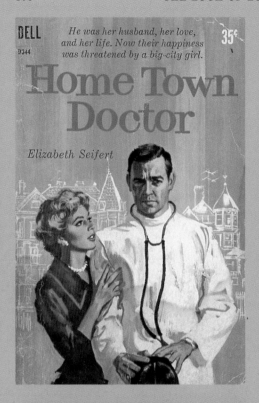

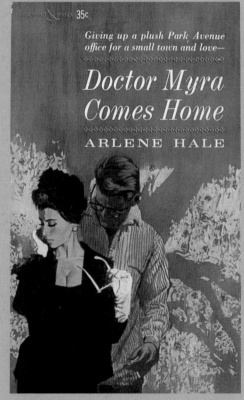

HOME TOWN DOCTOR
Elizabeth Seifert
Dell Books, 1960

DOCTOR MYRA COMES HOME
Arlene Hale
Airmont Books, 1963

THE DOCTORS
Clara Dormandy
Airmont Books, 1962

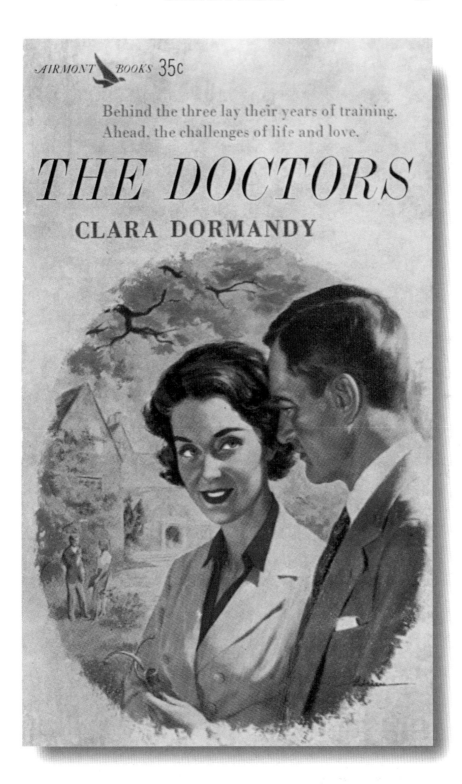

AIRMONT BOOKS 35c

Behind the three lay their years of training.
Ahead, the challenges of life and love.

THE DOCTORS

CLARA DORMANDY

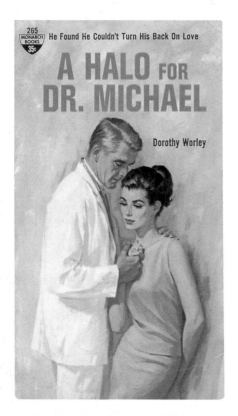

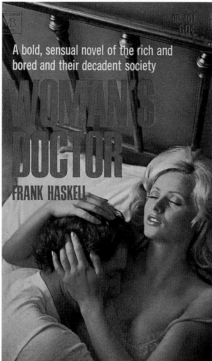

A HALO FOR DR. MICHAEL
Dorothy Worley
Monarch Books, 1962
Cover illustration by Tom Miller

WOMAN'S DOCTOR
Frank Haskell
MacFadden Books, 1969

YOUNG DOCTOR ELLIOT
Florence Stonebraker
Belmont Books, 1962
Cover illustration by Robert Maguire

□ □ The story of a young
doctor's struggle between
emotion and dedication □

YOUNG DOCTOR ELLIOT

By
FLORENCE STONEBRAKER
author of LOVE DOCTOR

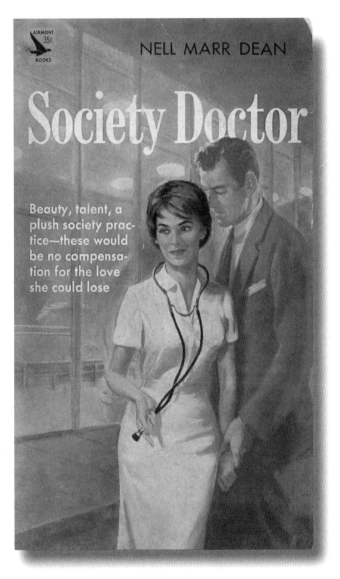

Hardcover publisher Thomas Bouregy & Company provided content for many paperback houses, including Bantam Books. In the early 1960s the company began publishing its own romance paperbacks under the Airmont Books imprint.

SOCIETY DOCTOR
Nell Marr Dean
Airmont Books, 1962

THE DOCTOR'S PRIVATE LIFE
Elizabeth Seifert
Signet Books, 1973

SIGNET•451-Y6314•$1.25

ELIZABETH SEIFERT

THE DOCTOR'S PRIVATE LIFE

Could two famous doctors survive the
scandal when the shocking truth about
their marriage was revealed?

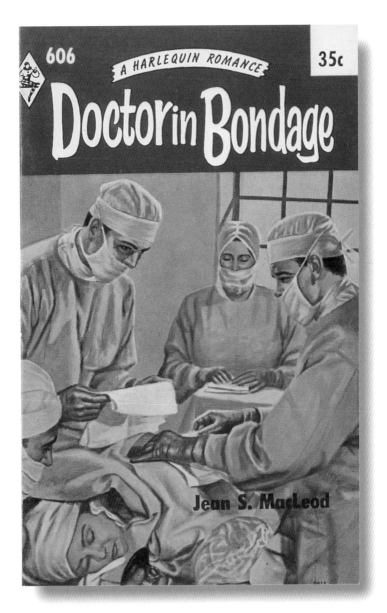

In the mid-1950s Harlequin began placing the titles of its books in bands of color with artwork below. This design helped distinguish the publisher from an increasing number of competitors.

DOCTOR IN BONDAGE
Jean S. MacLeod
Harlequin Books, 1961

DOCTOR IN BONDAGE

By JEAN S. MACLEOD

Doctor Bruce Kendron had remained "in bondage" to Janie because he had always blamed himself for the accident that had cost Janie ten years of helplessness.

Now, ten years after the accident, there was the question of an operation which could give Janie a fifty-fifty chance of getting better. Bruce knew in his heart that Janie was in love with him; so, although he had never performed this particular operation, he knew he could not refuse when Janie pleaded that he himself should do it.

But one other question remained unanswered. Did he owe Janie more? **Must he offer her, as well, the heart that he had given elsewhere?**

A **HARLEQUIN** *Romance*

Time Passages

S ome of the most popular romance novels feature characters and settings from the past, such as the antebellum South or Regency England. Margaret Mitchell's 1936 classic *Gone with the Wind* is the apogee of this genre. Covers for such books feature characters in stylized period dress performing "typical" scenes: a Southern woman in a hoop dress milling about a plantation home, for example. Romances with European locations come with the obligatory castle.

Gothics are perhaps the easiest to discern of all romance subgenres. While Gothic stories may take place in the present, the houses that provide their settings are from different, darker eras. The typical Gothic cover features a beautiful, fearful woman in the foreground with a foreboding mansion with a single lit window behind her. The heroine often has accepted a job in one of these haunted houses, as in Rona Randall's 1967 *Walk into My Parlor*: "Belinda Masters had recently learned that she wasn't an orphan, as she had always thought; she had inexplicably been abandoned at birth by her aristocratic mother. Then, in the midst of her confusion, fate stepped in: Belinda found a position in decaying Queen's Manor, where her mother dwelt in seclusion."

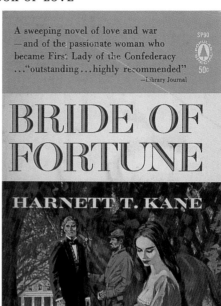

Historicals set in the antebel-
lum South nearly always had
covers featuring a large
plantation home.

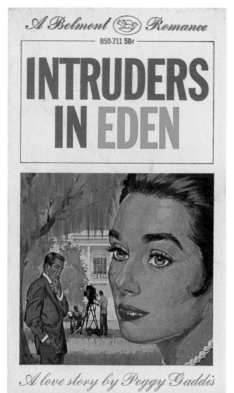

BRIDE OF FORTUNE
Harnett T. Kane
Popular Library, 1948

INTRUDERS IN EDEN
Peggy Gaddis
Belmont Books, 1967

SPRING GAMBIT
Claudette Williams
Fawcett World Library, 1976
Cover illustration by Alan Kass

2-3025-2•$1.50 FAWCETT CREST

A Captivating New Novel of
Love and Intrigue

SPRING GAMBIT
by Claudette Williams

A REGENCY ROMANCE

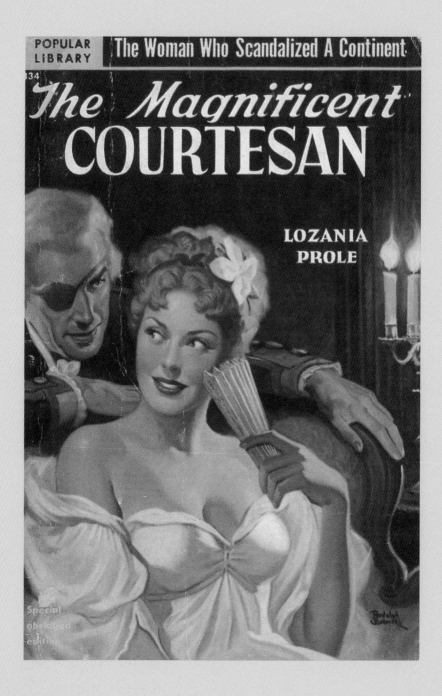

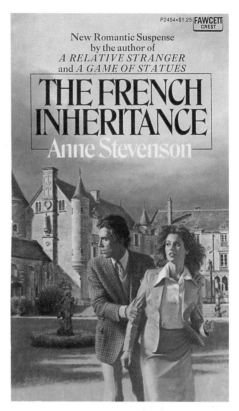

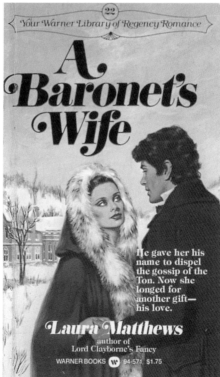

THE MAGNIFICENT COURTESAN
Lozania Prole
Popular Library, 1951
Cover illustration by Rudolph Belarski

THE FRENCH INHERITANCE
Anne Stevenson
Fawcett World Library, 1974

A BARONET'S WIFE
Laura Matthews
Warner Books, 1981

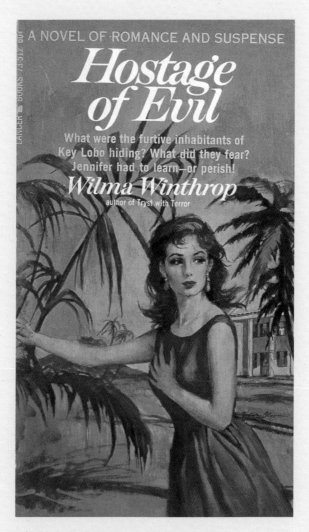

In the 1960s Gothic romances were
hugely popular. Inspired by such novels
as Daphne du Maurier's 1938 classic
Rebecca, the modern versions usually
featured spirited young women visiting
or working in a gloomy mansion inhab-
ited by peculiar characters.

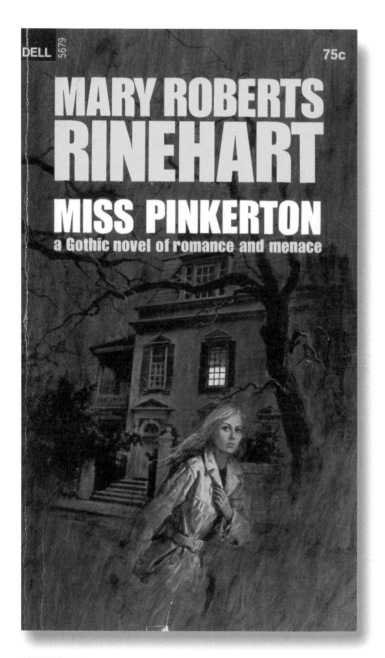

HOSTAGE OF EVIL
Wilma Winthrop
Lancer Books, 1966

MISS PINKERTON
Mary Roberts Rinehart
Dell Books, 1960

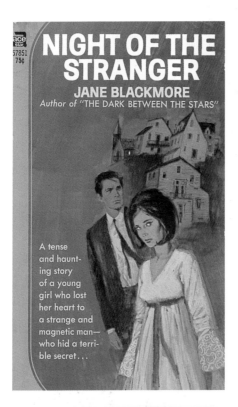

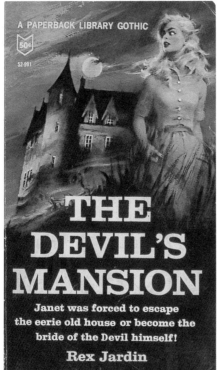

NIGHT OF THE STRANGER
Jane Blackmore
Ace Books, 1961
Cover illustration by Leone

THE DEVIL'S MANSION
Rex Jardin
Paperback Library, 1966

WALK INTO MY PARLOR
Rona Randall
Ace Books, 1967
Cover illustration by Robert Maguire

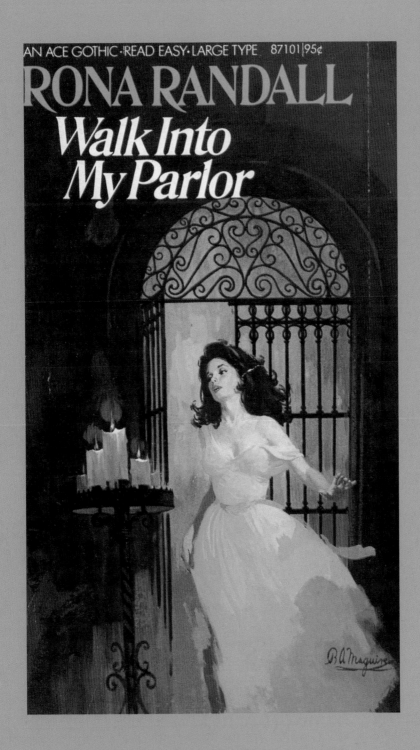

AN ACE GOTHIC·READ EASY·LARGE TYPE 87101|95¢

RONA RANDALL
Walk Into My Parlor

Exotic Encounters

Romance novels set in foreign lands are often stories of tempestuous love affairs and exciting sexual escapades. In the vernacular of the romance, even the most independent of women become vulnerable when they find themselves far from home. Such was the case in E. M. Hull's 1925 *Sons of the Sheik*: "Diana Mayo, English and headstrong and indifferent to the admiration and desire her beauty aroused in the hearts of men, journeyed into the African desert—there to be kidnapped and finally tamed into submission by Sheik ben Hassan, despotic ruler of a powerful tribe." These stories provided glimpses into different cultures, providing excitement and adventure along with a good love story. At best naïve by today's standards, they often perpetuated unappealing stereotypes of "natives," as with *Golden Earrings'* gypsy heroine Lydia, who has a "weird hodgepodge of wild and barbaric superstitions."

Stewardess romances, which became popular along with jet travel in the 1960s, thrust unsuspecting virginal women into exotic places and unusual love affairs. Often the plane itself was the setting for steamy encounters, as in Delphine McCarthy's 1965 *Beyond the Clouds*: "Pretty Pat Aylmer was a young stewardess flying on the New York to London run. Her captain was Robert Prentice—tall, dark-haired, and exceptionally good looking. What could be more perfect—the excitement of international flying shared with this handsome man?"

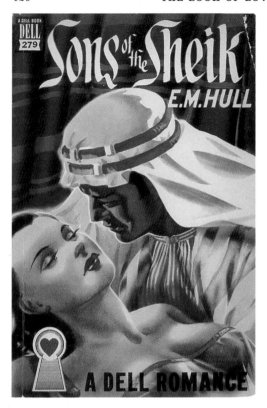

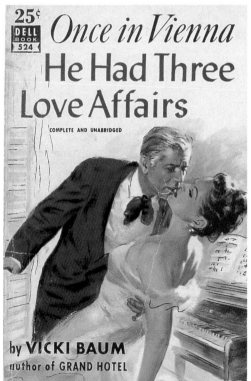

SONS OF THE SHEIK
E. M. Hull
Dell Books, 1925
Cover illustration by F. Kenwood Giles

ONCE IN VIENNA: HE HAD THREE LOVE AFFAIRS
Vicki Baum
Dell Books, 1945

WITH GALL AND HONEY
R. Leslie Gourse
Avon Books, 1961

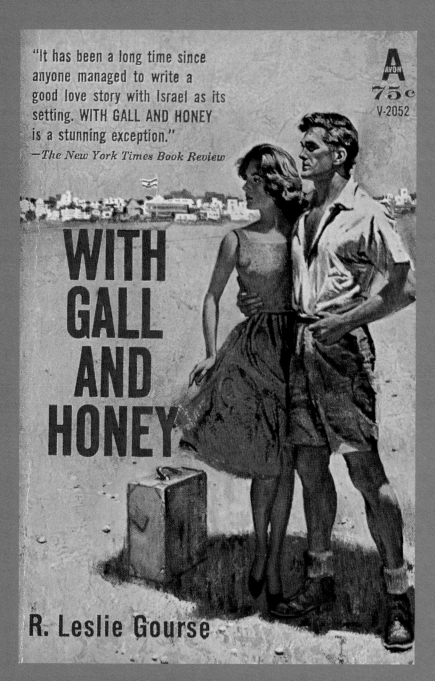

"It has been a long time since anyone managed to write a good love story with Israel as its setting. WITH GALL AND HONEY is a stunning exception."
—*The New York Times Book Review*

A AVON 75¢ V-2052

WITH GALL AND HONEY

R. Leslie Gourse

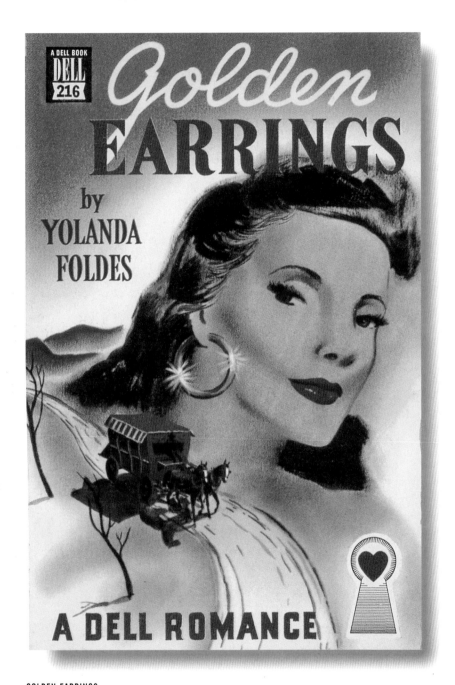

GOLDEN EARRINGS
Yolanda Foldes
Dell Books, 1946

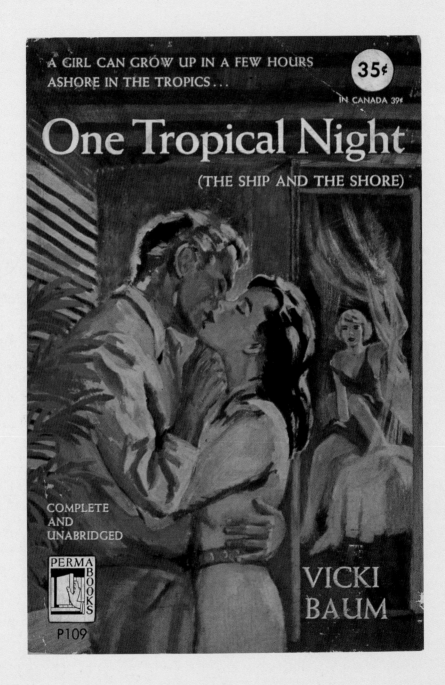

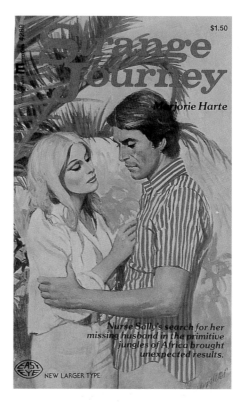

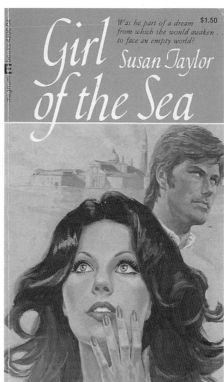

ONE TROPICAL NIGHT
Vicki Baum
Permabooks, 1951

STRANGE JOURNEY
Marjorie Harte
Magnum Books, 1971

GIRL OF THE SEA
Susan Taylor
Magnum Books, 1976

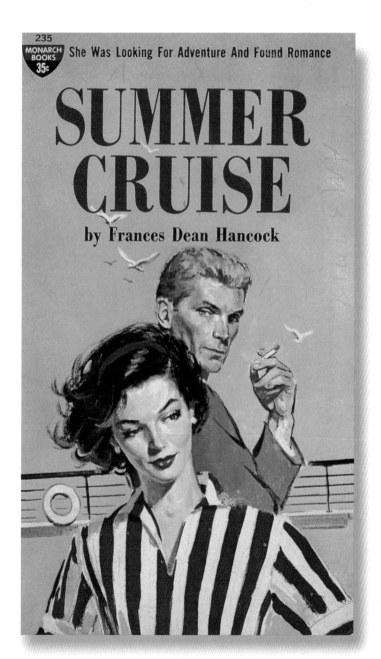

SUMMER CRUISE
Frances Dean Hancock
Monarch Books, 1962
Cover illustration by Robert Maguire

DARK SUNLIGHT
Jennifer Ames
White Circle Pocket Books, 1945

ROMANCE AND TROPICAL INTRIGUE

DARK SUNLIGHT

241

JENNIFER AMES

A COLLINS WHITE CIRCLE POCKET EDITION

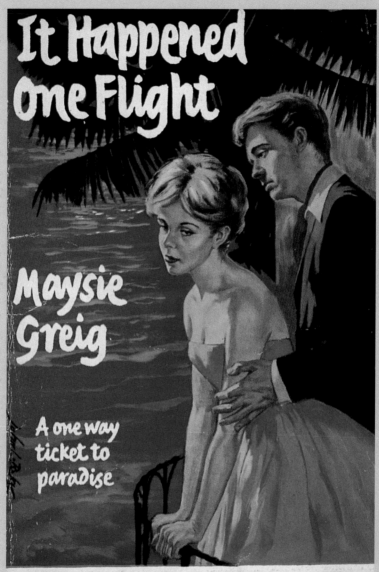

IT HAPPENED ONE FLIGHT
Maysie Greig
Fontana Books, 1961

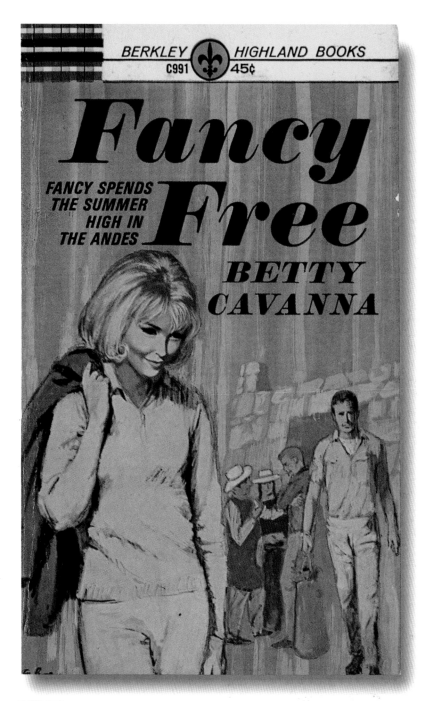

FANCY FREE
Betty Cavanna
Berkley Highland Books, 1964

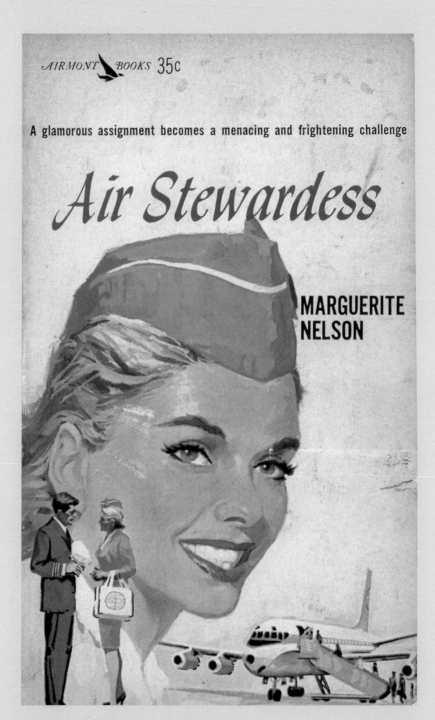

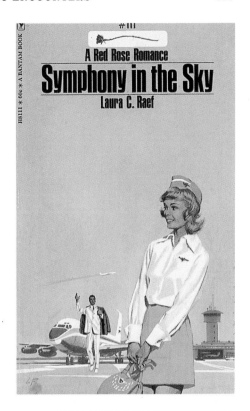

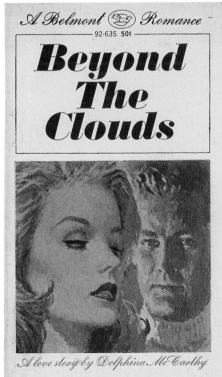

AIR STEWARDESS
Marguerite Nelson
Airmont Books, 1961

SYMPHONY IN THE SKY
Laura C. Raef
Bantam Books, 1971

BEYOND THE CLOUDS
Delphina McCarthy
Belmont Books, 1965

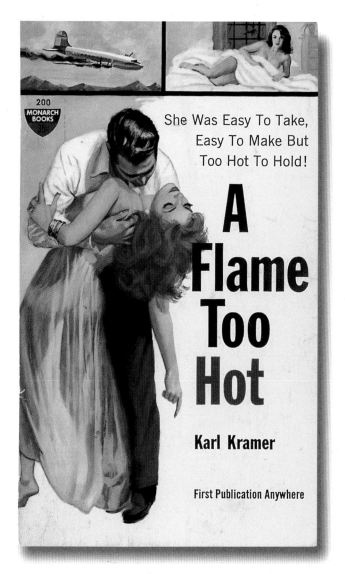

A FLAME TOO HOT
Karl Kramer
Monarch Books, 1961
Cover illustration by Harry
Barton

FLIGHT NURSE
Kathleen Harris
Bantam Books, 1962

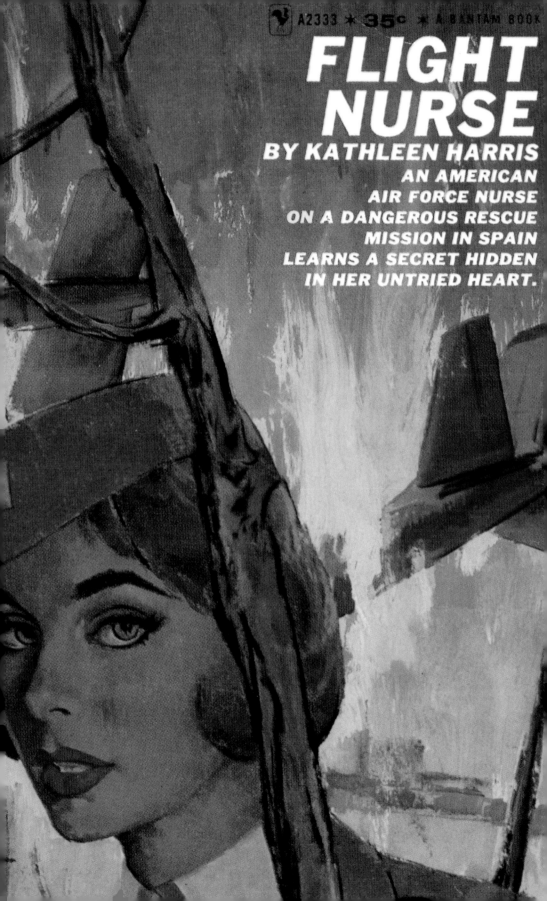

A2333 ★ 35c ★ A BANTAM BOOK

FLIGHT NURSE

BY KATHLEEN HARRIS

AN AMERICAN
AIR FORCE NURSE
ON A DANGEROUS RESCUE
MISSION IN SPAIN
LEARNS A SECRET HIDDEN
IN HER UNTRIED HEART.

Bibliography

ARTICLES

Abartis, Caesarea. "The Ugly-Pretty, Dull-Bright, Weak-Strong Girl in the Gothic Mansion." *Journal of Popular Culture* 13 (fall 1979).

Bonn, Thomas L. "The De Graff Autographed Collection." *Paperback Parade* 14 (August 1989): 40–44.

Brenner, Bruce and Roy G. James,. "The Maguire Touch." *Paperback Parade* 31 (October 1992): 45–69.

Gray, Paul and Andrea Sachs. "Passion on the Pages." *Time*, 20 March 2000.

Heller, Steven. "Mapbacks: High End of Low Art." *Print* 48, no. 3: 48–53.

Jolley, Elizabeth. "The House of Love: Passion's Fortune: The Story of Mills & Boon, by Joseph McAleer." *The Age*, 6 March 2000.

Lovisi, Gary. "Collectible Paperbacks." *Paperbacks, Pulps & Comics* (1995).

Ramsdell, Kristin. "The Literature of Romance: A Librarian's Viewpoint." *Romance Writers Report* 19 (June 1999): 37–39.

Starr, Marian. "Sweet-Savage Book: The Romance in America, 1855–1980." (1981).

BOOKS

Bonn, Thomas L. *UnderCover: An Illustrated History of American Mass Market Paperbacks*. New York: Penguin Books, 1982.

Crider, Allen Billy. *Mass Market Publishing in America*. Boston: G. K. Hall & Co., 1982.

Nell, Victor. *Lost in a Book: The Psychology of Reading for Pleasure*. New Haven: Yale University Press, 1988.

Radway, Janice A. *Reading the Romance: Women, Patriarchy, and Popular Literature*. Chapel Hill, NC: University of North Carolina Press, 1984.

Reno, Dawn and Jacque Tiegs. *Collecting Romance Novels*. New York: Alliance Publishers, 1995.

Scott, Art and Wallace Maynard. *The Paperback Covers of Robert McGinnis*. Boston: Pond Press, 2001.

Thirty Years of Harlequin. Toronto: Harlequin Enterprises, 1979.

Thurston, Carol. *The Romance Revolution*. Chicago: University of Illinois Press, 1987.

Walters, Ray. *Paperback Talk*. Chicago: Academy Chicago Publishers, 1985.

Zinberg, Marsha. *The Art of Romance: A Century of Romance Art*. Don Mills, Ontario: Harlequin Enterprises, 1999.

"That's what it's like, darling," said Mrs. Stokes uneasily. "Being a doctor's wife, I mean."

"I know," said Linette softly, her eyes starry. "Isn't it wonderful?"